Haunted Portsmouth

Haunted Portsmouth

Spirits and Shadows of the Past

Roxie J. Zwicker

CHARLESTON · LONDON

Haunted America

Published by Haunted America
A Division of The History Press
Charleston, SC 29403
www.historypress.net

Cover image: The South Cemetery is actually made up of several burial grounds.

First published 2007
Second printing 2008
Third printing 2012

Manufactured in the United States

ISBN 978.1.59629.233.8

Library of Congress Cataloging-in-Publication Data

Zwicker, Roxie J.
Haunted Portsmouth / Roxie J. Zwicker.
p. cm.
Includes bibliographical references.
ISBN-13: 978-1-59629-233-8 (alk. paper)
1. Ghosts--New Hampshire--Portsmouth. 2. Haunted places--New Hampshire--
Portsmouth. I. Title.
BF1472.U6Z95 2007
133.109742'6--dc22
2007011633

To my husband, Ken, you are my heart.
Thank you for your encouragement,
inspiration and love.

CONTENTS

INTRODUCTION

Portsmouth, New Hampshire, the nation's third-oldest city, was founded in 1623. Its settlement was founded after St. Augustine, Florida, and Richmond, Virginia. The area was first explored in 1603 by Martin Pring and later in 1614 by Captain John Smith, who was the first to make a map of the coast. This beautiful seaside community, originally named Strawbery Banke and renamed Portsmouth in 1653, will captivate your senses with all that it has to offer. Strolling down brick sidewalks in the shadows of its historic and elegant architecture, you will find yourself wondering who lived here and what fascinating stories they could tell. To best explore Portsmouth, park your car and walk around, as there are discoveries all around you. From the elaborate early colonial burying grounds to the maritime heritage and the fascinating residents, this jewel of a city will awaken your curiosities. Add to this picturesque and quaint setting the legends of ghosts and haunted locations, and you will find yourself transported through time and space simply by one visit.

Every street in Portsmouth seems to have been touched by some remarkable event in American history. Portsmouth was New Hampshire's state capital for about one hundred years—right up until the time of the American Revolution. Some of the fastest ships in the world came from the Portsmouth Naval Shipyard, which has operated since 1800. Today the Naval Shipyard maintains navy ships, modern, high-tech submarines and nuclear-powered ships. In 1905 Portsmouth was host to the signing of the Russo-Japanese peace treaty mediated by President Roosevelt.

One thing that you won't read about in any tourism guide is that Portsmouth holds the record for the city with the highest number of unsolved murders in the state of New Hampshire. This is surprising, considering that there are so many settled and urban areas of the state. Most of these murders actually took place during the nineteenth century. Before Portsmouth was a charming little seaside community, it was a rough-and-tumble seaport. Back then the city was a very different place

with a gritty past. Portsmouth has reinvented itself and is entering a golden age, where signs of urban renewal are gone and the architecture has been restored to its glory. People visit Portsmouth from all over the world to touch the past and learn about its famous residents and visitors.

Considering Portsmouth's extensive history and multitude of historic locations dating all the way back to a post-medieval home—the oldest structure, the Jackson House, dates from 1664—it is no wonder this place is haunted. Portsmouth is a place where buildings that are on the National Register of Historic Places are fairly commonplace. What secrets are contained in the walls of these places and who are the people buried in its graveyards? This book will introduce you to some of Portsmouth's notable citizens and eccentric residents. We will visit places with haunted stories spanning hundreds of years and others with more recent spirit encounters.

Merriam Webster defines "ghost" as follows:

ghost, *noun*.

1. the seat of life or intelligence
2. a disembodied soul; *especially*: the soul of a dead person believed to be an inhabitant of the unseen world or to appear to the living in bodily likeness

Portsmouth's early settlement and multitude of historic locations are bound to yield skeletons in the closet, and perhaps a few ghosts. When one imagines a haunted house, one may think of an old, abandoned Victorian mansion on a lonesome road lined with tall, shadowy trees. Yet, in some cases, these stories come from beautiful, meticulously kept historic homes—locations where people actively live, work and visit. In some of the stories we'll examine different types of paranormal activity—from playful spirits to less friendly entities. When you visit some of these places, you can sometimes feel the character of the location just by standing on the doorstep. The question is, do you dare take a look inside—really inside? Brush the dust off of the local books, delve into old newspaper archives and ask questions and you will see these places truly take on lives of their own.

I certainly don't expect everyone to believe in ghosts; I just ask that you open your mind to the possibilities. Some people are simply fascinated by the history, and that is a great place to start. Let the history be your guide and you may be surprised where it leads you. And for those who love a good ghost story, Portsmouth has many to offer. Portsmouth's past is very much the history of America—from its earliest settlement to the evolving

city that it is today, Portsmouth feels old. You turn a street corner and almost expect to find yourself carried back hundreds of years in time.

From the first time I visited Portsmouth, I was drawn back, always looking to visit another home, to see another view of the Atlantic from the base of the lighthouse, to walk in the footsteps of people I had only read about in history books. Throughout all of my early visits I never guessed that my fascination would also include uncovering ghost stories. The more people I talked to over cups of clam chowder and glasses of hard cider, the more ghost stories I found needed to be told for the first time.

I never would have thought to walk into a local establishment and ask, "Do you happen to have any good ghost stories?" Nowadays, you might be surprised to hear that as soon as I walk into these places, people come up to me and tell me their latest spectral tale or sighting. These stories will keep the history alive, but also send shivers down your spine. The stories seem to evolve over time. The more you visit the same places, especially with different groups of people, the more different impressions you get. Sometimes different people relay identical experiences without even knowing it. Therein rests an intriguing fascination. How many more places are yet to be discovered and how many more stories are yet to be told?

Here I have assembled stories that I have personally experienced and some that have been told to me. All have been thoroughly researched in newspaper archives, books and existing records. Each place has a history and a story to tell in its own unique way. Let us begin our journey into the historic past and into the stories of ghosts and legends from Portsmouth, New Hampshire.

POINT OF GRAVES BURIAL GROUND

Consisting of about a half an acre, the Point of Graves burial ground is one of New Hampshire's oldest cemeteries. Officially established in 1671 as Portsmouth's first graveyard and deeded to the town by Captain John Pickering, it is one of the most fascinating places to visit in the seacoast region. The tall pines that border this quiet cemetery create long shadows that lead to tombstones of grinning skulls and somber cherubs. The burial ground was once surrounded by the Piscataqua River and took its name from the land on which it is situated. Portions of the river were filled in and made into public gardens in the early twentieth century, creating an even more scenic setting, but placing the river farther away from the burial ground. It is said that burials of the Pickering family took place here before 1671; however, due to scarce records we may never know how old this burial ground truly is. The oldest stone dates from 1683 and interments ended in the late nineteenth century.

The graphic depictions of death on many of the stones reflect the Puritan influences of the time. The Puritans taught that death is inevitable and is God's punishment for the original sin of Adam. The stones and their carvings were meant to serve as reminders of one's mortality on this earth, and they still strike that very chord three hundred years later. Depicted here are images of colonial beliefs and superstitions. Another belief was that at death some people would receive eternal salvation as a gift bestowed by God, but most would face eternal damnation. Hell was said to be a place of "unspeakable terrors."

When you step into the cemetery you are greeted by a groaning swing gate, as if you are about to pass through a portal in time. Many notable people are buried here, such as Captain Tobias Lear, father to the secretary of George Washington. Samuel Wentworth, father of Lieutenant Governor John Wentworth, is also buried here.

Immediately upon entering, you will notice the iron turnstile—a rarity in New England cemeteries. When Captain Pickering gave the land to the

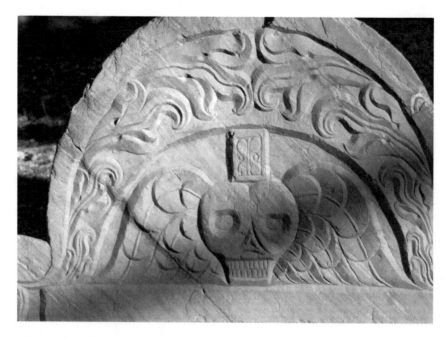

Elizabeth Pierce's dramatic tombstone dating from 1717 is located in the Point of Graves burial ground.

town, he still allowed his cows to graze on the property, even after burials began. The turnstile was designed to keep the animals out and allow the visitors in. The land here is noticeably uneven, due in part to the roaming animals and in part to the fact that the underground tombs have collapsed over the years. The peacefulness of this place—called the "Ancient Burial Ground" in the 1800s—seems to lure in the inquisitive.

The gravestones were hand carved by some of the finest stonecutters of New England. The more basic funerary carvings in New England during the seventeenth through early nineteenth centuries consisted of an early "death's head" or "winged skull" style (late 1600s through circa 1790), which gave way to a "cherub's head" style (circa 1760 through 1810), which was in turn displaced by an increasing preference for the "urn and willow" style (circa 1770 through mid-1800s). The date ranges of these shifts, and the character of developments within each of these stages, varied from locality to locality within New England, and the Point of Graves burial ground showcases a variety of stylistic interpretations. Most of the stones here date from the eighteenth century, but there are also many from the seventeenth and nineteenth centuries. It seems almost

impossible that many of these stones have survived over two hundred and fifty New England winters. These finely detailed stones are waiting to tell their stories, and are worthy of appreciation and acknowledgement.

At one time, local writer and historian Thomas Bailey Aldrich said that the graveyard itself was dead—referring to its overgrown and neglected condition. For many years it was nearly impossible to walk the grounds because of the thistles, tall grasses and even wild strawberries that shrouded the stones. Today you will find neatly trimmed grass and several recently restored stones—as well as spirits of the past. Do these spirits shadow visitors as they inspect the slate stones and ponder the existence of the departed? It is quite possible.

You can very easily lose track of time in the graveyard as you stop to read the inscriptions on the stones. There is a very beautiful stone for William Button, who died in 1693. This is one of the most elaborate carvings in Portsmouth. William Button died when he fell overboard one of his own ships as it made its way down the Piscataqua River. The stone has two intricately carved angels, each detailed right down to their teeth. There is also an hourglass, a tiny winged skull (a soul effigy) and a pinwheel representing the cycle of life. There are fruits depicted along the sides of the stone. At first glance, the stones don't seem to be over three hundred years old. This is just one example of what exploration of the burial grounds will yield.

For many years, stories persisted about the Point of Graves being haunted. According to rumor, just one visit may indeed make you a believer. I heard tales of people who claimed to hear footsteps behind them, only to turn around and see no one there. Some people even said that they felt like they were being watched. I thought that perhaps their surroundings were influencing their imagination. The dozens of hand-carved skulls with their vacant eye sockets on these stones can be striking and a little unnerving.

One quiet August afternoon I was taking pictures of the carvings and found that as I walked away from one particular stone, I felt a nudge or a small push behind me. Startled, I turned around quickly and found no one there. The only other person in the cemetery at that time was my husband, who was nowhere near me. I wasn't really sure what I had experienced. Then the tales of people being followed came to mind. Was I just imagining this? Could this have happened? I was certain I had felt something besides my heart racing as I rushed toward the gate. Over the next couple of years, my feelings of that afternoon were confirmed. On numerous occasions before the tours begin, people comment that they were in a certain part of the cemetery and felt a "push." When asked to

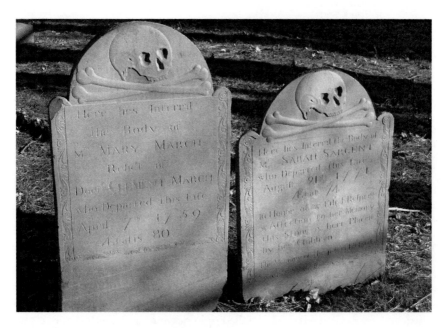

There are many wonderful images in the Point of Graves. These stones were carved by Homer of Boston, Massachusetts.

identify the location, they always select the grave of Elizabeth Pierce, who was buried there in 1717. Her stone is a remarkable colonial gravestone carving, with a winged skull and an hourglass where all of the sand has run out (symbolic to remember that time is fleeting). She is thought to have passed away from consumption at the age of forty-two, and she has no relatives buried here with her. The numerous people who described being "pushed" at her stone all maintain that it happened as they were walking away from her grave. The thought is that perhaps she is lonely and attempting to get attention so that people do not walk away from her grave. On one occasion there was a little girl about six years of age who, while inspecting the stone very closely, looked up with all sincerity in her eyes and said, "You know, she's very lonely and sad."

On another occasion, while a group of about fifteen people—including a local newspaper reporter who later chronicled the experience in an article—were walking away from Elizabeth's stone, a most unusual formation took shape in the sky. On what had been a dark and cloudy day—with no sun and no light in the sky—the sky above the graveyard changed. A few small pink wisps of clouds were pointed out by numerous

people who exclaimed that they looked like angels. While this sight only appeared overhead for a few moments, you could easily discern a body and angelic wings on each figure. This pink formation stood out against the blackened sky and was simply awe-inspiring.

Another area of the graveyard has its own share of activity. In one of the farthest corners of the Point of Graves is the Vaughn tomb. The marker stands on a high point on the grounds and is an excellent place to get the lay of the land and an overview of all of the stones. People have maintained that whenever they take a picture of the stone, orbs or light anomalies appear in their images. I can tell you that there is a small streetlight behind the stone, but people have displayed pictures taken from different vantage points and varying backgrounds and the orbs are always there.

I had an extremely odd experience while viewing the stone with a flashlight at night. It had been a dry day with a moderate temperature and no moisture in the air. In explaining the Vaughn family's notable past, I often use my flashlight to highlight the engravings on the stone. As the light from my flashlight illuminated the gravestone, a stream of water began to pour from a seam in the stone, as if an invisible faucet had been turned on. Water poured out for several minutes, but the rest of the tombstone remained dry. Cameras clicked away only to reveal a number of orbs in the images. Upon return to the graveyard later that evening, the water had stopped, but there was still a damp trail on the stone. Coincidence or something else, I'll let you decide.

There is another area of the graveyard that stirs emotions in some visitors. One tall, slanting tombstone lists the sad death of two children, both under the age of three, who died from Portsmouth's yellow fever epidemic in the 1790s. A ship belonging to local merchant Thomas Sheafe came back to port from the island of Martinique carrying coffee, molasses and the dreaded yellow fever. The epidemic killed nearly one hundred people and struck families especially hard, sometimes taking all of their children. Visitors have said that they felt a tremendous sadness when approaching the stone—before hearing the tragic tale. Several people have quickly walked away from the stone grief-stricken and believing that they felt the physical presence of a parent at the stone bent down in mourning. If your footsteps lead you to the Point of Graves, you will find that this burial ground exists to display beautiful stories and images on stone, and perhaps to offer a spirited experience on occasion.

Portsmouth Harbor Lighthouse

If you make your way to Portsmouth via boat on the Atlantic Ocean, you will be welcomed to port by way of the beautiful Portsmouth Harbor Lighthouse. The warm, green beacon of the lighthouse can be seen as far as twelve nautical miles out to sea. This important lighthouse station was the first established north of Boston in 1771, making it the tenth of the original eleven colonial lighthouses. In 1793, President Washington ordered that the lighthouse be maintained at all times, with a lighthouse keeper living on site. The lighthouse stands on the tiny island of New Castle, which was part of Portsmouth through part of the eighteenth century. New Castle Island is only about three-quarters of a square mile and the village features many seventeenth- and eighteenth-century homes. The lighthouse was established to guide mariners to the mouth of the Piscataqua River, which leads directly to the Portsmouth docks and waterfront.

Today the cast-iron paneled and brick-lined lighthouse stands on an active coast guard base and adjacent to Fort Constitution. The current structure was built in 1878 and it stands forty-eight feet high. The lighthouse is now automated; the last lighthouse keeper left in 1948. An all-volunteer group, the Friends of Portsmouth Harbor Lighthouse, maintains the lighthouse. Their responsibility is to take care of the maintenance and upkeep of the lighthouse, as well as make it accessible to the public through educational open houses. As a volunteer myself, I couldn't resist the lure of the lighthouse. It seemed to be a connection to a time that was forever retained in the pages of history books.

The long walkway that leads to the door of the lighthouse affords visitors wonderful views of the seacoast, as well as a large variety of maritime traffic ranging from commercial freighters to pleasure craft. In the summer, harbor seals sun themselves on rocks surrounding the lighthouse and cliff swallows tend to their carefully constructed nests that are tucked underneath the walkway surrounding the lantern room. As you stand in front of the lighthouse you cannot help but notice its wonderful

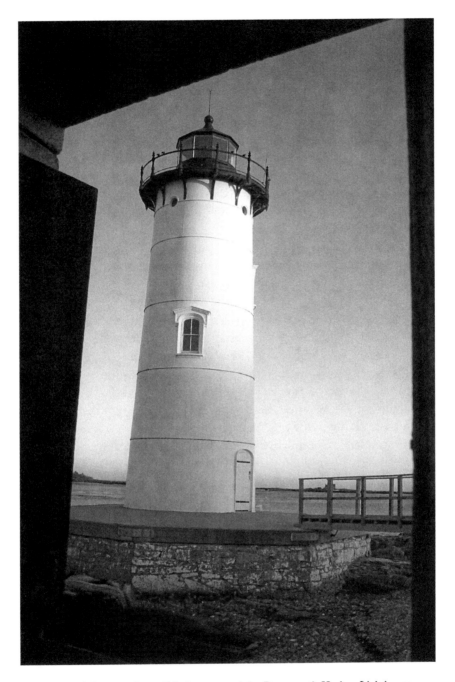

This is one of the many beautiful views around the Portsmouth Harbor Lighthouse.

condition. Certainly the efforts of the Friends group are evident, but is this group assisted by spirits of the past—spirits who also take pride in the care and maintenance of the lighthouse? Perhaps the ghosts of keepers past still keep their silent watch from this storm-washed beacon.

When ghosts first made their appearance known at the lighthouse they revealed themselves to some unlikely people. Some of the first stories of unearthly happenings came from volunteers of the Friends group who claimed that at different times they heard a male voice blurt out some words very quickly. On each occasion the volunteers were alone in the lighthouse—one person was taking down holiday decorations and another was painting the stairs. Each did not know of the other's experience, but described the same exact sound and occurrence to another group member. In fact, one of the volunteers claimed never to have believed in ghosts until that moment when he realized that there was no one at the lighthouse except for him and this mysterious voice from beyond.

One day I was contacted by producers at the History Channel who were looking to film a pilot episode for a show called *Psychic History*. The premise was that a well-known psychic would be brought to a location—without knowledge of its history or background—and attempt to find a haunting or psychic impression. With the recent incidences at the lighthouse, I suggested that we have the investigation there. My first impression of the psychic, John Holland, was that he was intuitive and rather laid-back. Upon arrival at the lighthouse he made mention of a man in a dark suit or uniform, with a gray beard—a bit of an "Old Salt." He said that this spirit was very attached to the lighthouse; he had an unmistakable connection and wanted to be there. John was also puzzled by the mysterious letter "K" that kept coming to mind. As he climbed the spiral staircase and passed by one of the windows, John claimed that he felt a strong presence standing at the window. As he climbed to the lantern room, John felt that this spirit was one that had been at the lighthouse for a long amount of time and never wanted to leave.

At this point, it was explained to John Holland that he was describing characteristics of a lighthouse keeper who kept the light at Portsmouth Harbor for thirty-five years. Joshua Card seemed the embodiment of John's portrayal of this spirit. Joshua was basically forced into retirement in 1909 at the age of eighty-five; he never wanted to leave the light. He always wore a keeper's uniform that proudly displayed the letter "K" for keeper, and Joshua would often tell many people that the "K" stood for captain. True, he did

have a large gray beard and did have the features of a well-weathered Old Salt. He was proud of the lighthouse, as many keepers were, and took his position quite seriously. Had it been Joshua, the lighthouse keeper, speaking to the volunteers at the lighthouse in that very gruff voice?

The coast guard was another unlikely source of ghost stories relating to the lighthouse. There were a number of witnesses to these stories, which added to the credibility of the legends of the lighthouse. Tales included hearing mysterious sounds and feeling the presence of another person in the lighthouse tower. Even more intriguing were some of the strange sightings that had happened on overnights. One eerie account detailed the sighting of the specter of a woman in a long gown walking along the seawall that led to the lighthouse. She appeared on the closed circuit monitors, and yet when you looked out the window, there was no one walking along the seawall. Several people clearly saw this apparition. A group had gone outside to take a closer look, only to find no one there. Watching this mystery woman walk along the seawall on the monitor and seeing nothing out the window was just another of many chilling experiences that happened in the shadow of the lighthouse.

Mysterious footprints that appeared one evening across the helicopter-landing pad baffled members of the coast guard. As the grounds are monitored at all times, one has to wonder how they got there. The story relayed to me was said to have been witnessed by many people over the period of three days. Apparently these footprints—one pair adult-sized and the other pair child-sized—were very well defined right down to the toes. The footprints met toe-to-toe right in the middle of the helicopter pad. They seemed to appear out of nowhere and while they appeared wet, they were actually a bit oily, and did not evaporate until three days passed. Stranger still was the fact that they went about thirty yards, disappeared behind one of the buildings on base and then seemed to go right into the water.

Soon the opportunity arose to do an overnight investigation at the lighthouse with a group called the New England Ghost Project. This team of experienced ghost hunters from the Dracut, Massachusetts area had over three hundred investigations in their history, but none had taken place at a lighthouse. Their group consisted of a psychic medium, Maureen Wood, who could communicate with the spirits of the departed. Also taking part in the investigation team were an EVP (Electronic Voice Phenomenon) specialist, night vision camera operators and other video

The Portsmouth Harbor Lighthouse is an icon of the New Hampshire seacoast.

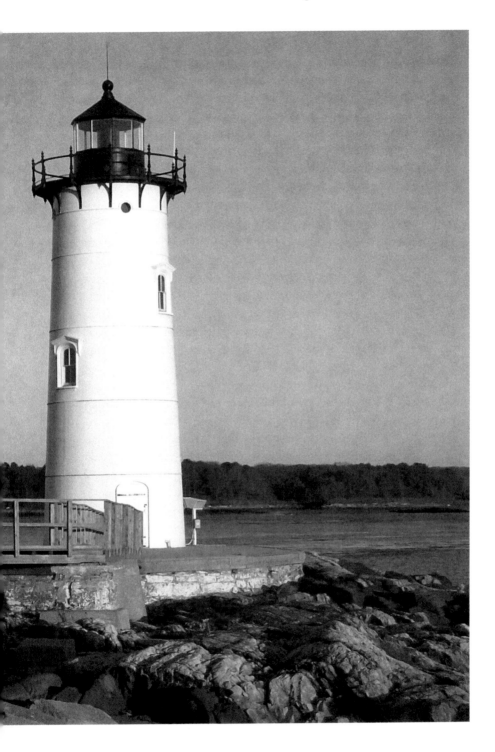

specialists. The group was led by Ron Kolek, who had set up base camp in the bottom of the lighthouse. Base camp consisted of a series of recording devices and monitors ready to capture any visiting or lingering phantoms.

No one from the Ghost Project knew anything of the previous investigation's results or the personal accounts of haunted activity. This was the first time they had visited the lighthouse, but this was not their last time—especially after the events of the night unfolded. Joshua Card seemed to make an appearance again at the lighthouse. Maureen described him almost identically as John did, right down to the mention of the letter "K." The Ghost Project's EVP specialist, Karen Mossey, set up out on the walkway around the lantern room. Her mission was to collect voice recordings on her electronic recorder. She asked short questions and tried to capture responses from the spirit. While the investigation team watched the monitors, everyone saw Karen attempting to make contact. She said that she was getting a response when she asked, "Who was here?" She then played back the response, and if you listened very closely, you could discern the word "Captain" in response to her question. As Maureen climbed the spiral staircase to the watch room, she said that she felt a heaviness in her chest and that it was becoming difficult to breathe. She maintained that she was picking up a very strong spirit, an almost tangible feeling.

Exploring the area around the lighthouse brought us to the area behind the lighthouse keeper's house. While the group was getting ready to stop and take a break, the EMF (Electronic Magnetic Field) readers began to go off all of a sudden. The closer to the ground they were moved, the stronger the readings became. Maureen explained that she was picking up a female spirit kneeling on the ground and gardening. Maureen maintained that this woman communicated that she was there as a companion to a man, the lighthouse keeper. The era she described the woman being from seemed to fit in with the time frame of Joshua Card. While Joshua was at the lighthouse, he was indeed a bachelor; however, it would not have been unheard of for him to have a visiting lady friend companion. As soon as Maureen said that the woman stopped communications, the EVP meters went dead, with no readings whatsoever.

What happened next took this investigation to a new level and prompted answers to the question—"Do you believe in ghosts?" While inside the lighthouse keeper's house, which was built in 1872, an otherworldly experience unfolded. The house had been converted into offices and was no longer used as accommodations. The coast guard maintained that the sounds of someone walking around were coming from areas of the house that had been sealed off and were inaccessible. That night, more than just sounds

came from the house. On the second floor of the house, Maureen claimed to come in contact with a "sweet woman," one of the "warmest and friendliest" spirits she had ever encountered. At the end of a small hallway, her encounter with the beyond became all too real. Maureen explained that this woman had passed away fairly recently and wanted to be at the lighthouse, that lighthouses were her life. According to Maureen, the spirit was glad that people were coming to visit the lighthouse, almost as if they were coming to see her personally. Maureen said that this peaceful soul wanted to send the message of "thank you." The chairperson of the Friends group had been in attendance throughout the evening, and felt that if this was the person he was thinking of, he wanted to say, "you're welcome." Maureen went on to say that she could see that the spirit was holding something in one hand and reaching out her other hand, wanting to hug someone. When I asked Maureen what the spirit was holding, she specifically said flowers with large pink buds. At that moment a chill went down my spine, and I could feel emotions welling up inside. Maureen asked the spirit if she had any further messages to give and told her that if she did not, she could go. Maureen then became overcome, lost consciousness for a moment and fell to the floor, knocking over a chair. Ron picked Maureen up and asked the spirit to go. Later it was discovered that a photograph taken of the chair revealed a face in the floor.

We regrouped on the first floor of the house to go over what had just happened. Maureen was in tears and everyone seemed a bit stunned by what had transpired. Maureen and the Ghost Project then learned the story of Connie Small. There are times in your life when you meet that very rare person you cannot help but admire and be inspired by; Connie Small was one of those people. Connie was the wife of Elson Small, a lighthouse keeper, and for twenty-six years they tended to some of the most remote light stations in Maine. I was lucky enough to meet Connie—an artistic and resourceful woman who saw the beauty in so many things—when she was one hundred years old. I had seen Connie on television telling her inspiring story as a lighthouse keeper's wife for a show on PBS. She inspired me to visit my first Maine lighthouse, and not too long after, to move to Maine. She was an author and lecturer, and she spoke about lighthouses across the country. Her book, *Lighthouse Keeper's Wife*, penned when Connie was in her eighties, is a glimpse into her amazing legacy. The cover photograph showed Connie and Elson in front of the Portsmouth Harbor Lighthouse. Elson and Connie Small were the last civilian lighthouse keepers at Portsmouth Harbor Lighthouse and the Friends group had made Connie their honorary chairperson. To this day,

I treasure the stories she told me about her life and times at the lighthouse. I was truly saddened by her passing earlier that same year, although I was amazed that she lived to be one hundred and three years old.

On the day of Connie's funeral, I wanted to bring something to give to her. Knowing that she always tried to maintain a garden wherever she went, I picked up some pink tulips for her. I placed a handwritten card with a lighthouse on it inside the sleeve of flowers. I expressed my admiration and said my goodbye. After the services, I waited to be the last one to step up to Connie's coffin. I was overcome with sadness at the thought that I would never meet anyone like her again. I didn't know what to do with the flowers. Tears ran down my cheeks. The minister told me if I wanted to, I could place the flowers inside the coffin. As I said goodbye and left the flowers, I knew I had lost a friend. That night with the Ghost Project, as I heard Maureen talk about the flowers in Connie's hand, and her reaching out in thanks, I experienced a feeling that words can never describe. No one from the Ghost Project was at Connie's funeral, and certainly there was no knowledge of the flowers that were left for her.

The chairperson of the Friends group, Jeremy D'Entremont, was a bit surprised as well because it was his wish to someday make the lighthouse keeper's house a museum, and to name it after Connie Small as a tribute. Emotions ran strong and deep during those final moments in the keeper's house. It was decided that since it was then nearly 3:00 a.m., it was time to pack up for the night—but not before one last amazing moment. After the equipment was removed from the base of the lighthouse tower, the door was locked and a collective sigh taken, something drew close and made everyone run back into the lighthouse. This August night was crystal clear. Stars filled the sky and the temperature was quite comfortable. As the group began the journey down the walkway to the stairs toward the parking area, a wall of fog moved in around the lighthouse. The green beams of the Fresnel lens pierced the fog and the swirling mist enveloped us. The group decided to return to the lighthouse and we stepped out onto the walkway around the lantern room to witness this mysterious fog. Viewing this wall of shadowy, green clouds from the top of the tower was one of the most incredible sights; the moment was surreal. Maureen and Karen had the impression at that moment that the spirits were saying goodbye. Within minutes this phenomenon had passed, but upriver the fog bank had disappeared. The stars reappeared in the crystal night sky. As everyone made their way back to their cars, it was agreed that this was a very special night, and the lighthouse needed to be visited again very soon.

FORT CONSTITUTION

The first defense fortification guarding Portsmouth harbor was built in 1631 on an ideal site at the mouth of the Piscataqua River. A timber blockhouse built in 1666 replaced the original structure—an earthwork structure called the "Castle." In 1692, the fort became known as Fort William and Mary and was named after British aristocracy. In 1771, Portsmouth Harbor Lighthouse, the ninth lighthouse built in the colonies, was constructed of wood inside of the fort walls, and was later moved just outside the fort in 1804.

Many people are surprised to learn of the fort's important role in the American Revolution. Everyone has at some point heard of the famous midnight ride of Paul Revere to Lexington, Massachusetts, on the night of April 18, 1775. Revere proclaimed the arrival of the British. He placed lanterns in Boston's Christ Church—one light if they were to arrive by land and two lights if they were to arrive by sea. However, in December of 1774, just months before this legendary act, Paul Revere rode to Portsmouth in what is considered the very first act of the American Revolution.

Paul Revere rode from Boston with a message that British troops were coming on two ships to obtain the ninety-seven barrels of gunpowder kept at the fort. He brought the message to Stoodley's Tavern, where the Revolutionary militia—the Sons of Liberty—gathered, and to Samuel Cutts, who was the head of the Portsmouth Committee. No time was wasted in assembling a group of approximately four hundred men and boys to storm the fort and prevent the British from obtaining valuable munitions. The six British soldiers guarding the fort fired a few shots—the first shots fired in the Revolutionary War—but they were no match for the riotous mob. One of the first actions taken by the group was to lower the British flag that had so proudly been flying in the breeze. The powder was immediately loaded into boats and the next day military stores and one small cannon were also removed. It is said that the king was so infuriated at this blatant action that at that point he knew there were no hopes of

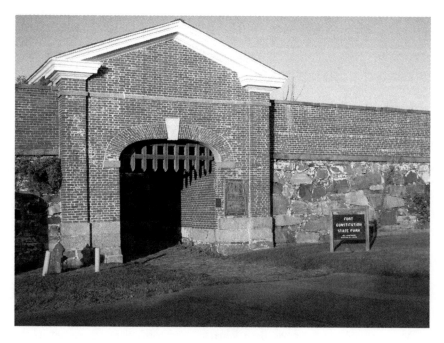

The entrance to Fort Constitution welcomes visitors.

the colony's concession. It is said that much of what was seized at the fort was used in Boston at the Battle of Bunker Hill.

The impending Revolution caused John Wentworth—the royal governor of New Hampshire—and his family to seek protection inside the fort in 1775. He was then forced out of the colonies and forced to leave North America until 1792, but he never did return to his beloved New Hampshire. After the American Revolution in 1808, the name of Fort William and Mary was changed to Fort Constitution, a symbol of the new nation's independence.

However, it was during an Independence Day celebration on a hot July 4, 1809 day that the fort saw its worst tragedy and most bloodshed. Visitors from the town and officers of the fort had gathered for the festivities, including dancing and music. Colonel Walbach was hosting many guests in his home at the fort for lunch during this time. But the afternoon's festivities were cut short with a shocking boom from a tremendous explosion. A spark on the ammunition chest was blown by the wind, which caused over three hundred pounds of powder to explode. Seventeen cartridges and numerous cannonballs were launched throughout the fort. The devastating scene was one of utter chaos and

indescribable terror. One man's entire body was blasted over the roof of the colonel's house. Another man's leg was blown off and thrust through the door of the same house. Other bodies were tossed nearly one hundred yards around the fort, like cloth dolls. The gruesome discovery of another body was made at low tide next to the lighthouse, at quite a distance from the explosion. Nine people were killed, including three soldiers and three local teenage boys. Numerous others were injured. The colonel described the incident as worse than that of any war he had encountered.

Fort Constitution was expanded in anticipation of the war of 1812 and a tower was added in 1814. Work on a three-tiered granite wall began in 1862, but work was halted in 1867 with the thought that stone forts were archaic. Several buildings and batteries were constructed in the early 1900s. The fort played an important role during World War I and several observation stations were added. During World War II, these observation stations served as a lookout for German U-boats and mines. Part of the property became the Portsmouth Coast Guard Station and the majority of the property was transferred to the state of New Hampshire, and some areas of the fort were restored in 1974.

Today the fort is a wonderful place to visit and has some of the best views of the seacoast. From across the water you can see the Block House at Fort McClary and the fortification at Fort Foster in Kittery. Some of the short tunnels are open for exploration and parts of the gun turrets are still visible. You can easily see the many layers—representing different time periods—contained in the fort walls. The main parade is a sweeping expanse of well-manicured grass perfect for a lazy Sunday picnic. Groundhogs now inhabit the fort. You might almost miss their burrowed holes surrounded by wisps of grass.

A few paranormal investigations at the fort have yielded curious results. A segment of the show *Psychic History*, filmed by the History Channel, contains the results of a walk-through with psychic John Holland. As our group made our way around the fort, John said he could not understand why he kept seeing the number four in his mind. Another thing that puzzled John was the pungent aroma of gunpowder and fire. While walking in the area of the 1809 tragedy, John claimed to have sensed several deaths taking place. Not ever having visited the fort or knowing the history of events, it was quite a revelation to tell him the stories after the walk-through.

Two other investigations done at night with the New England Ghost Project seemed to raise more questions about the fort's haunted history. The

Fort Constitution provides a view of Portsmouth Harbor Lighthouse.

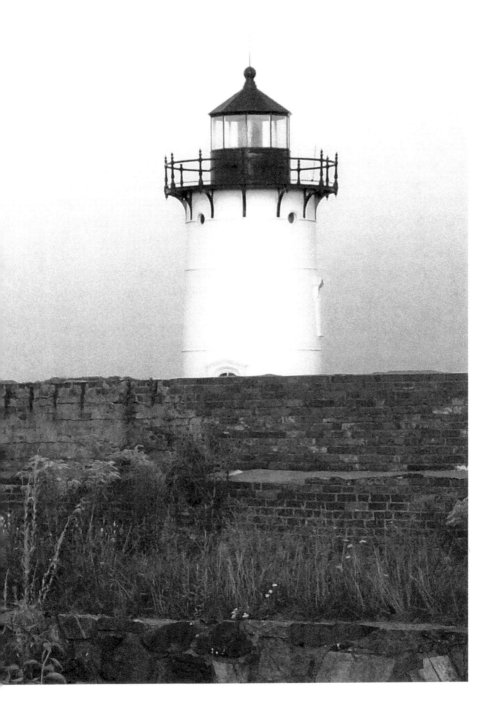

Ghost Project, like John Holland, was unaware of the history or incidents in the fort's past. While they echoed the impressions that John mentioned regarding the number four and the smell of fire, their exploration brought out a more spirited encounter. The Ghost Project's psychic Maureen Wood described communicating with a spirit who was unable to leave the fort because of overwhelming guilt for something that had happened. Maureen stated that the spirit she was channeling couldn't understand why it had survived this terrible "accident" and that it wished it could have stopped the accident. She claimed that she had a difficult time getting the spirit to leave her because it was so emotionally distraught.

One investigation with the Ghost Project allowed the public to join the quest and invited them to bring along their cameras and flashlights for the nighttime exploration. While many people claimed to get orbs of one nature or another, there were some pictures that warranted a closer examination that night.

One gentleman in the crowd stayed behind the rest shooting pictures after the group had walked away to the next location. He was prompted to share some of the first images he took in the fort that night with others in the group. Three particular images in his collection stood out. All three shots were taken in the entryway to the fort, where it was quite dark. One image revealed a ghostly mist in front of the Sentry Room, which was built in 1808. Another image revealed a green streak moving from left to right in the entryway, and upon closer examination, the image clearly revealed a green leg in motion. The third image also revealed a green streak moving back and forth, but in the black background there were three moving green and yellow lights. These undulating lights are clearly not reflections of anything in the entryway. The background details of the fort entrance are crisp and clear, so it is easy to discern that the camera itself is not moving. Lights of this nature are often described as being a vortex, or doorway, into the paranormal world.

For nearly four hundred years there has been activity at this site in one form or another. Is it impossible for us to believe that some of this activity may be of a paranormal nature? Walking through Fort Constitution you are sure to get a glimpse of its fascinating history, but will you catch a glimpse of a ghost? Bring along your camera and sense of adventure and you may be surprised at what develops.

THE MUSIC HALL

Standing in the shadow of the historic Music Hall on Chestnut Street in downtown Portsmouth, you can't help but be transported back to an earlier era. This is a place that has transitioned through times of opulence and times of despair, and yet through it all the Music Hall has prevailed and today is the seacoast's premier performing arts center.

This location has a compelling and fascinating history, which may lend itself to some of the unexplained and mystifying occurrences over the years. In the early eighteenth century, the nation's very first almshouse, or poorhouse, was built right on this site. Because of the large number of destitute individuals, Portsmouth built six houses throughout the city in the later eighteenth century. Rules were strict, as this was basically a workhouse and it was customary for those who moved in to make the immediate acquaintance of ten lashes with a whip. This was to serve also as a warning of what might be in store for those who didn't follow the rules. Interestingly enough, many of the residents of the house weren't always indigent; in fact many captains' widows ended up there when their husbands didn't return from their long voyages at sea. In many cases the wives had exhausted their entire fortunes and were penniless—often having sacrificed their homes to pay outstanding debts.

Some of the other characters at the almshouse had their own distressing stories. One of the residents, who lived there rather quietly, was a young local girl named Miss Colbath. Dear Miss Colbath was working for a local boarding house owned by Mrs. Woodward. As the legend goes, Miss Colbath tended to remain at the boarding house hours after her work was done, and she was often seen leaving the rooms of the single gentlemen boarders of the house. One evening Mrs. Woodward saw Miss Colbath leaving one of the rooms with two bottles of alcohol in hand, and surmised how she "earned" those bottles. It is said that Mrs. Woodward confronted her on the spot, fired her and demanded that she never come back to the property.

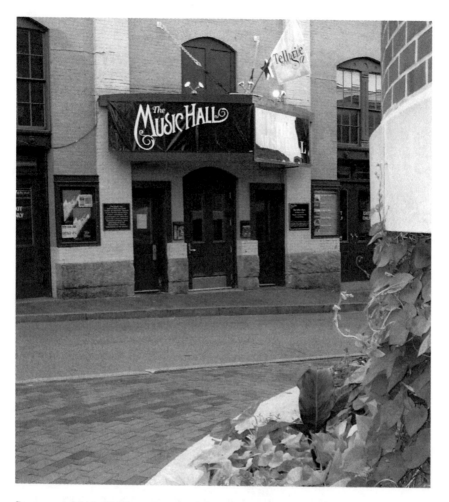

Portsmouth Music Hall has entertained thousands throughout its history.

Miss Colbath went over to a friend's house after the incident, and told them that she was going to go back later that night and set fire to Mrs. Woodward's barn. Well, late on that cold and windy December night in 1813, a fire did break out in Mrs. Woodward's barn. Quickly the fire spread across town, the hot cinders blowing from rooftop to rooftop. The intense fire raged for three days and its glow in the sky could be seen as far as Boston, Massachusetts. In the end, 108 shops, 64 dwellings and more than 30 barns were lost in the Great Fire of 1813. The fire burned down most of State Street and stopped only when it reached the Piscataqua River. Miss Colbath's friends kept her secret for the rest of their lives and no one was ever held accountable for the

fire, although Mrs. Woodward certainly had her suspicions. It is said that immediately after that incident, Miss Colbath moved into the almshouse, which was just a couple of streets over.

Another interesting soul at the almshouse was Molly Bridget. Molly made it known to visitors and everyone in town that she was a fortuneteller and that for a price she could tell your future. At a time when superstition was commonplace, people thought that Molly had either made a deal with the devil, or perhaps was a witch. Otherwise, how could she make these fantastic predictions? Well, it just so happens that one day Molly was passing by a local farmyard and for whatever reason, the chickens couldn't lay eggs and the cows stopped giving milk as soon as she strolled by. The farmer believed that Molly had bewitched the animals. He decided to pay a visit to the local minister to find out how to break this "curse." Apparently the minister told the farmer to go back to the farmyard and cut the tails off of the pigs and burn them at Molly's residence. Not thinking how outrageous this sounded, the farmer proceeded with his task of cutting off the tails and burning them in the doorway of the almshouse. When he returned to the farmyard later that day, much to his disappointment, he found the animals to be even more agitated. He visited the minister once again, terrified of what was happening. He still couldn't imagine what he had done to be so cursed. This time the minister told the farmer to cut the ears off of the pigs, burn them at Molly's residence and the curse would then be broken.

The superstition at the time was that a witch would often place an imp or mischief-maker into the ear of an animal to cause it to carry out her curse or do her bidding. The belief was that cutting off the ear and burning it would cause the imp to jump out of the fire, scream the witch's name and break the curse. Evidently this sounded logical to the farmer and he then cut the ears off of the pigs, returned to the almshouse and set them ablaze in one of the fireplaces. The tale then goes on to say that Molly Bridget ran from room to room in the almshouse shrieking in unnatural horror, and when the fire died out, Molly Bridget dropped to the floor, dead. Was the curse broken, or did Molly simply have a heart attack? Well, no one stopped to ask questions at that point. Her body was quickly removed and she was buried in an unmarked grave. It was said that as her remains were lowered into the ground one of the most severe storms of its time blew into port. What of the farmer's curse? The story goes that when he returned to the barnyard, the animals were calm and there were no further disturbances.

After the almshouse, a temple was built in the location. However, in 1876 it burned to the ground. On January 29, 1878, the Music Hall opened to much local fanfare. It became a place of assembly and community, as it was used for everything from graduations to pony shows. Most of all, it brought entertainment to this old town by the sea. The variety of acts and shows brought out a large number of people from the population. In 1900, the property was purchased by none other than the "King of All Ale Makers," Frank Jones. He purchased the property because he had a lady friend who was an aspiring opera singer. He renovated the Music Hall with an opulence that was as over-the-top as the neighboring Rockingham House. One of the most striking features Jones added was a proscenium archway that features the face of Bacchus, who has been named "Frank" by the staff. In the three short years that Frank Jones owned the Music Hall, it became a showpiece of architectural design. The ornamentation of the Music Hall was stunning with its fluted columns reaching upward to the detailed plaster cherubs playing instruments.

After Frank Jones passed away, the Music Hall changed owners and, sadly, it closed in 1926. A bad business deal and competition from four other newer theaters in town were its undoing. At that point, the Music Hall had hosted many acts, including a show by master illusionist Harry Houdini. Many legends about Houdini claim that he was an intense performer, always leaving an impression wherever he visited. In 1945, the Music Hall reopened as the Civic Theater, but in 1971 it was purchased by Lowe's theaters and closed down so it would not be in competition with their other theater, the Colonial. Dark days drew near for the Music Hall, and rumors circulated that it might be torn down, a victim of urban renewal. However, in 1987, a group called the Friends of the Music Hall was formed, and through public and private donations the property's future was secured. It is currently undergoing an extensive restoration and is being brought back to the time of Frank Jones.

What could be more intriguing than a haunted theater? Visions of ghostly spirits taking the stage night after night for rows and rows of empty seats come to mind. However, the numerous ghosts at the theater aren't only in the spotlight on the stage. Reports of activity in other areas of the theater are quite common. As you enter the lobby of the Music Hall you will find spacious staircases to the left and to the right leading up to the second floor. It's been said that after hours when the guests have left for the night and while the receipts of the day are being tallied in the lobby box office, sounds of people going up the staircases

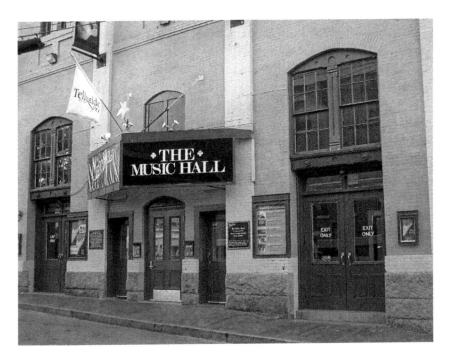

The Portsmouth Music Hall is New Hampshire's oldest theater.

are fairly commonplace. However, when these sounds are investigated, no visible source of these disturbances can be found. In some instances, two employees will go to explore the noises. They will split up—each taking a separate staircase—but when they meet on the second floor there is no one to be found, which leaves them quite perplexed.

Speaking of the second floor, when visiting the right side balcony area, you may want to bring an extra jacket. The employees of the Music Hall speak of a large cold spot—an area where the temperature drops dramatically, as if a cold, dead soul is standing beside you. They claim to have researched any heating and ventilation concerns and have found nothing that could be causing it. A radio show also conducted an investigation at the Music Hall and concluded that the balcony area was haunted and the cold spot very pronounced.

On the subject of cold experiences in the theater, a local gentleman who regularly cleans the Music Hall after performances described an incident one very late summer night. On what was a stifling hot night, he was alone in the Music Hall vacuuming near the middle rows of the

first-level seating area when an ice-cold breeze startled him and sent shivers up his arms. Knowing that the air conditioning was not on, he looked around to see if anyone had walked by and found that there was no one there but him. He claimed to be so certain that there were spirits there that every night when he left and closed the door, he told the spirits, out loud, to have a good night.

Some people maintain that when they visited the location in the 1960s, when it was showing movies, they actually saw the lighting apparatus swinging overhead as if being blown by a mysterious wind. Other visitors discovered strange shapes moving along the walls—as if someone was walking by—only to look around and find everyone seated. One of the legends of the Music Hall was that they actually kept a black cat on the property for several years to keep the spirits at a distance. Stories have also been relayed that when some visitors are enjoying the show a full-size shadow person steps right in front of their seat, blocking view of the stage. People have been said to reach out, as if to move the person along the row, only to find that they are grasping at just the empty air in front of them.

There are many secrets still being uncovered in New Hampshire's oldest theater. In 2007, extensive renovations, including restoration to the dome, were done in the theater. Astonishingly, an original neoclassic mural, complete with Roman soldiers, columns and filigreed scrolls, was discovered. It is believed to be from 1901 and had been plastered over for many years and was never documented. This leads us to the story of the Phantom of the Music Hall. Hidden on a wall near the lobby is the painting of a masked character wearing a colonial hat. An employee of the Music Hall uncovered it and it was quickly dubbed the Phantom of the Music Hall. One thing that many people who visit the theater do not know is that during all performances, a single light bulb is lit off stage and is called a "ghost light." The hope at the Music Hall is that when this light is lit, the phantom or ghost will stay in the shadows and not bother any of the visiting patrons during the performances. So, if you decide to take in a show at the Music Hall, be aware that there may be a part of the audience that only makes itself known through chilly breezes and phantom shadows.

Molly Malone's Irish Pub

On the corner of State Street and Penhallow Street in downtown Portsmouth you'll find a cozy little Irish pub. The pub—situated in a brick building that dates from approximately 1815—actually feels like a house. As you climb the stairs to the second-floor pub you'll see murals of a buxom young Molly Malone, selling her wares in Dublin Square, on the wall along the staircase. With its gorgeous fireplaces, comfortable window seats and plenty of imported brews on tap, you can't help but want to make yourself at home. It is said that spirits, those of the ghostly kind, also make themselves at home at Molly Malone's. The building served as a rooming house during the 1800s, but up on the second floor, each room also came with a female companion. This location was just one of over forty brothels that operated in Portsmouth right through the early 1900s. Some houses of ill repute had unusual ways of attracting clients and introducing the latest working ladies. One of the most famous houses, the Gloucester House, just down the street from Molly's, paraded the women through the center of town by horse and carriage, quite often returning with many men in tow. However, the ladies working at this location simply had to perch themselves up in the windows and wave to passing men to get their attention. At this time Portsmouth was a city of about six thousand full-time residents. There were 120 drinking saloons and between ten and fifteen thousand sailors came into port every single week. The police department had their hands full with only two full-time police officers—and one full-time police commissioner who was always down in the red light district either accepting a payoff or enjoying the company of the women.

It had not occurred to me to visit Molly Malone's to ask about ghosts until a Travel Channel producer suggested that perhaps there were spirits of another kind at the pub. In between filming takes of my ghost tours they told me that they had visited this pub and had met the owner, who had many paranormal tales to tell. I never would have guessed to stop in and ask about ghosts. However, after talking to the former pub owner, Jeff Cutter,

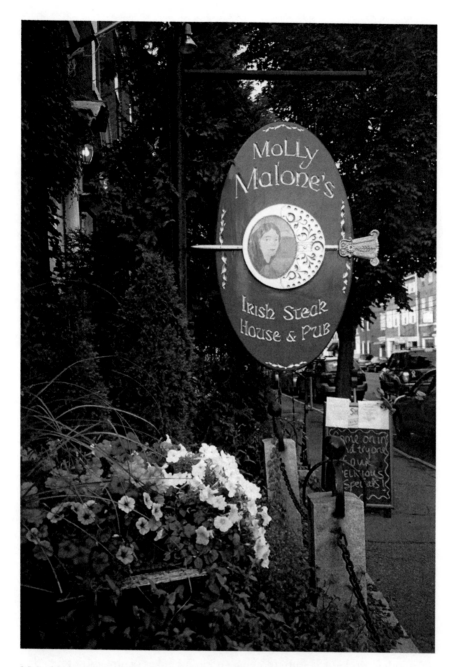

Molly Malone's is a favorite local spot for delicious food—and spirits.

on several occasions, I learned that he believed that two ladies still looked out the windows late at night, trying to get the attention of those passing by. These two ladies have been described as wearing nineteenth-century gowns and waving to those who walk along State Street. The pub owner was not the only one to see the lovely ladies; several people living and working in the neighboring buildings also reported sightings of the two women. In the building right next door to Molly's lived two sisters who, in their nineties, told stories of seeing the ladies peering from the windows. The former owner also felt that these ladies were rather friendly, claiming that they liked to play pranks on customers as well as the people who worked at the pub. He described several examples of the ghosts having a little bit of fun. At the end of many evenings, staff checked on the first-floor ladies' bathroom and found the stall doors locked—with a slide lock—from the inside. Because the bathroom is very tiny, there is less than a half an inch between the floor and the bottom of the stall doors, making it completely impossible for someone to reach inside and lock the door. Jeff described many occasions when they actually had to break open the door to make sure that someone hadn't passed out from one Guinness too many, only to find no one there. Some of the cooks have described feeling someone tug at their arms or at the back of their hair, but seeing no one there. One cook even claimed that one night the volume on the radio went up by itself after the dishwasher exclaimed that he liked the song on the radio. He said that he turned around to witness the volume display actually going up all on its own.

One customer told one of the employees that one evening just before closing time, he saw someone come into the dining room, sit down and then disappear right before his eyes. One of the waitresses said that some nights she would be the last one in the building and after she shut off the lights and locked the doors she would look up from outside on the sidewalk and see the lights lit on the second floor. She said that she didn't care if the owner took the cost of electricity out of her paycheck; there was no way she was going back inside.

Another waitress described a pretty vivid experience in the basement of the building, as she was finishing up her shift one night. She said that she was in the middle of the basement completing her tasks for the day when she looked down to the far end of the basement and saw a figure standing in there in the shadows. He was wearing a long white coat, which she thought might be a lab coat. What made her uneasy was that she could not see a face on this individual. She was about to call out to the shadow person when all of a sudden he came toward her, quickly walked

by and went up the stairs to the first floor. She decided to follow after him, wondering to herself if perhaps he was a cook. She justified this thought by realizing that cooks wear long, white coats. After she climbed the few steps and turned the corner to the first floor, she found no one there. At this point she returned to the basement to carry out the remainder of her tasks. When the waitress stood in the same spot where she had seen the shadow person, she again looked down to the darkened area of the basement. To her surprise, she saw the same figure in the long, white coat standing in the shadows. She couldn't believe what she was seeing. The basement only had one way in and one way out, and he would have had to walk by her again. Still curious, she got up her nerve and decided to walk down to the darkened area of the basement and find out for herself. She said as she got closer to the figure, it started to back away from her toward the wall and finally when she reached the end of the basement it disappeared right into the wall. The waitress said that she was as sure of what she saw in the basement as she was of the fact that she was telling me the story. It was later discovered that in the 1950s, the basement of the building was used as an apothecary, where it would not be uncommon for someone to wear a long, white lab coat.

It should also be noted that there is a walled-up, arched tunnel— possibly dating from the nineteenth century—in the basement of Molly Malone's that goes underneath Penhallow Street. A fascinating image of an owl has materialized from the weathered bricks. It is also rumored that human bones were discovered in the basement. Identification of the remains is uncertain and I have not been able to uncover any confirming documentation. The current owner feels the entity so strongly in his basement office that he has refused to be down there alone. The defining moment for him was when he stepped out of the office and saw a tray table stand set up at the bottom of the stairs, yet there was no one around and he did not see or hear anyone come down the stairs. There is a feel of something moving about the area, and temperature gauges tend to fluctuate tremendously in the basement. Entities have also shaken the dishes in the kitchen at the top of the stairs. During one investigation, the dishes were shaken quite loudly in the dark kitchen. There were no trucks going by and there was not a disturbance anywhere else in the area.

The former owner, Jeff, also mentioned several instances in which he thought that the ladies were being protective. He had said that he used to be in a partnership with another gentleman who didn't spend a lot of time at the business. One day the two of them were having a rather heated discussion at

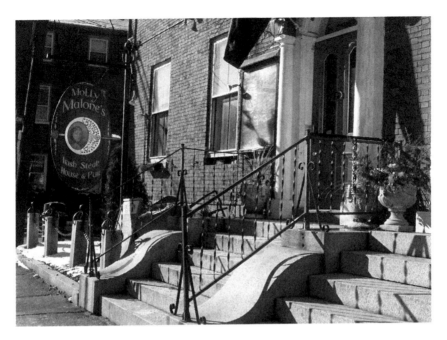

Molly Malone's is known as a favorite haunt of ghostly spirits.

the bar on the second floor and all of a sudden the glasses that were stacked up at the end of the bar flew off the bar in the direction of his partner. The bartender was not near the glasses and they all flew off at once, not one by one. Several people witnessed this incident. Strangely enough, just about two weeks later the scene began to repeat itself. The two men were having a similar discussion at the bar. This time when the glasses flew off of the bar they shattered on the wall across from the bar. It seemed a coincidence that shortly thereafter, Jeff purchased his partner's share in the business. He felt that the ladies enjoyed having people coming and going out of the pub and they didn't want to have it stop anytime soon.

On one of my regular tours I mentioned to my guests that I was doing some research on the ghost stories at Molly's. One of my guests from Portland, Maine, asked if we could stop in front of the building. Throughout the tour he seemed very intuitive about some of the stories I was about to tell, which I found quite fascinating. When he stood at the bottom of the stairs to Molly's he turned to me and said, "You know, there are five ghosts here." He then proceeded to point out various configurations of five all around the building. He pointed out five steps, five windows, five posts and five wires going into the building, as well as

many other configurations of five. At the time I didn't know anything about five ghosts, but I was interested to see if I could come up with five.

In September 2007 I was fortunate enough to investigate Molly Malone's with the New England Ghost Project. The investigation presented me with more information and consequently more questions. Many exciting moments occurred that night. Some of the most revealing were told by Maureen, who channeled the sprits. She was able to identify one of the spirits by name—"Lily" claimed to be from 1862. Lily often wandered from window to window, peering out, "looking for her friends." Maureen described her as wearing a long gown that swept the floor and brushed by the tables. During the same investigation Maureen stood in front of the underground tunnel in the basement of Molly's and channeled another spirit. After a few quiet moments, Maureen burst out and shouted, "Where's my woman?" The raspy, but loud voice was shocking when it bellowed, "You took my woman!" When I asked Maureen who she was, the response I received was, "Daniel." Maureen's breathing became quite labored and she had to push this spirit out of her, and we lost communication with Daniel. The group in attendance was quite startled by the encounter.

I learned that after the building became a legitimate rooming house in the 1920s—after the red light district was shut down—there was a sad death on the second floor. A drifter had come to Portsmouth looking for work, and when he didn't show up to pay his rent, the door to his room was broken open and he was found dead inside. Because he had very little identification on him, no next of kin was notified and he was buried in a pauper's grave. His belongings were put out on the street for the locals to pilfer. Perhaps he has lingered behind with no other place to go. One afternoon I brought a tour to Molly's and one of the guests went to use the men's room on the second floor. After a half hour passed, he came back and said, "The weirdest thing just happened." He said that he knocked on the bathroom door to see if anyone was inside, and when he got no response he began to open the door. Then he said he heard a very gruff voice shout out, "I'm in here." Closing the door quickly, he stood there and waited, and waited. After about twenty minutes he said he knocked on the door again, heard no response and then opened the door to find the bathroom empty. He said he never walked away and that there was no chance anyone could have walked out while he waited. There are no windows in the bathroom, nor any other exit out. Therefore, if you happen to be walking down State Street and you find yourself beckoned to Molly's, you may find yourself enjoying your spirits with a ghost or two.

THE UNFORTUNATE TALE OF RUTH BLAY AND THE SOUTH CEMETERY

The largest burial ground in Portsmouth, the South Cemetery, is actually made up of several smaller cemeteries. South Cemetery is the final resting place for many local residents whose life stories fill pages in area history books. On the corner of Sagamore Avenue and South Street, a group of several graveyards make up a very expansive and beautiful area. The entire Cotton cemetery was moved across town to this location—one of Portsmouth's oldest burial grounds, established in the seventeenth century. Also here you will find Auburn Cemetery, the Proprietor's Burial Ground, Sagamore Cemetery and Harmony Grove. The cemetery was designed in the garden style with walking paths and lanes. Visually it is a wonderful journey through time showcasing various burial styles and traditions. Here you will find eighteenth-century winged skulls, an Egyptian styled sarcophagus, mausoleums and hundreds of examples of Victorian funerary images.

Several notable people, including Revolutionary War soldiers, ship captains and a Supreme Court justice, are buried here. Rich and poor, famous and not so famous share permanent residency. Flowering trees of all types have been planted throughout the grounds, which makes the area even more inviting. While things seem rather peaceful these days, these grounds were also the point of assembly for many of Portsmouth's hangings in the eighteenth century.

In 1768, Ruth Blay, a young schoolteacher from Hampton, New Hampshire, found herself pregnant with an illegitimate child. After delivering the stillborn child herself, she was so frightened of the consequences that she buried the baby beneath the floorboards of the school. A young student of Ruth's witnessed the unfortunate incident. The student went home to tell her parents that she thought that Ruth murdered her baby. Ruth was then arrested and brought to trial. She was quickly found guilty and sentenced to death. Several reprieves were issued to halt the execution, but finally she was sentenced to hang on

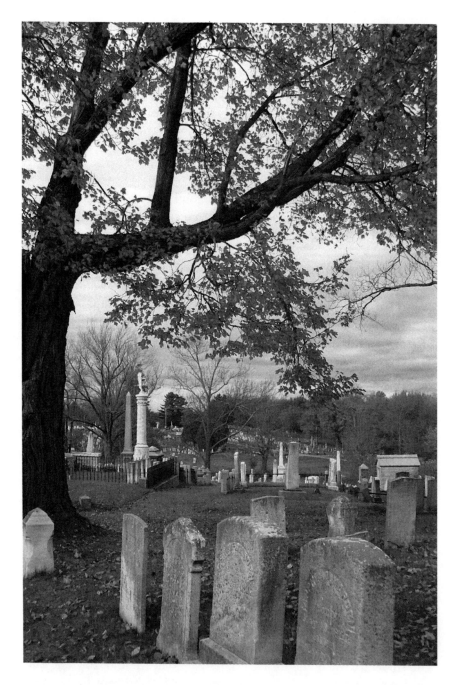

The South Cemetery is actually made up of several burial grounds.

December 31, 1768, in what is now the South Cemetery. At the time, over six hundred crimes were punishable by death.

Sheriff Packer was to preside over Ruth's hanging and he had heard that a final governor's reprieve was being issued. According to the story, the sheriff was planning on having his dinner on time that day—precisely at noon—and insisted the hanging take place at the designated hour, despite the fact that a reprieve from the governor had been issued. Ruth was brought by cart across town and her screams were heart wrenching as she pleaded her innocence. People in the crowd assembled to witness Ruth's agonizing end implored Sheriff Packer to wait for the pardon to arrive. At the stroke of noon, annoyed by the crowd, the sheriff quickly ordered the cart drawn away. Ruth Blay's body hung from the hangman's noose, twisting in the frigid winter air. Moments later, the clattering of a horse and rider brought the governor's pardon to the hand of Sheriff Packer, in the shadow of Ruth's now deceased body. The townspeople could not believe the callous way that Sheriff Packer handled the incident, and later that night an angry mob showed up at his home. The group burned an effigy of him on the lawn and they shouted all sorts of foul things at the house, expressing their sheer disgust.

Now at this point you might think that Sheriff Packer was removed from office and run out of town, but he remained sheriff for a few more years and died quite wealthy. Ruth Blay was quietly buried in an unmarked grave in the area near the pond at the cemetery. The state of New Hampshire did away with the death penalty a short time later, and it's ironic to think that the last person executed was an innocent woman. The tale was memorialized in the "Ballad of Ruth Blay," published in Thomas Bailey Aldrich's *An Old Town By The Sea*. The following is an excerpt:

> *Ballad of Ruth Blay*
> *by Albert Laighton (1859)*
> *And a voice among them shouted,*
> *"Pause before the deed is done;*
> *We have asked reprieve and pardon*
> *For the poor misguided one."*
> *But these words of Sheriff Packer*
> *Rang above the swelling noise:*
> *"Must I wait and lose my dinner?*
> *Draw away the cart, my boys!"*

South Cemetery, a garden-style burial ground, is home to beautiful trees and fascinating graves.

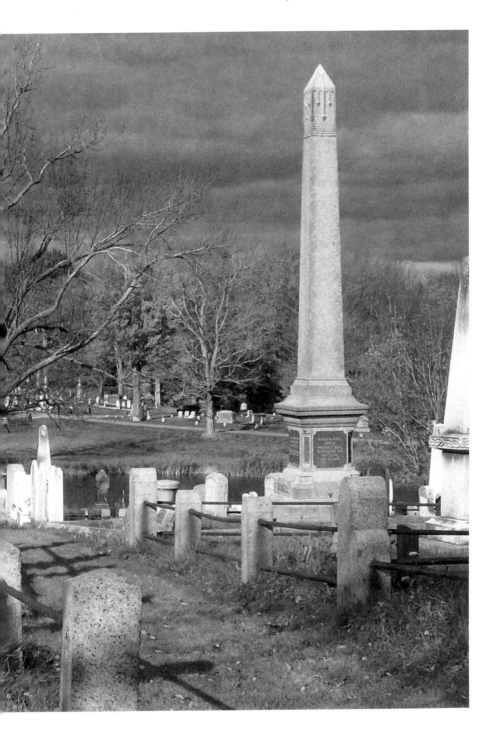

Nearer came the sound and louder,
Till a steed with panting breath,
From its sides the white foam dripping,
Halted at the scene of death;

And a messenger alighted,
Crying to the crowd, "Make way!
This I bear to Sheriff Packer;
'Tis a pardon for Ruth Blay!"

Some people claim that during sunset you can often feel something—or someone—pulling at your clothes, as if just making his or her presence known. Many others have said that sunset is a great time to do spiritography, the study of ghostly images on film. Some people believe that this photography is a type of communication between the spirit world and the current consciousness, or plane, in which we exist. Spirit photography has been around since 1839 and has intrigued millions around the world. Should you decide to try it for yourself, bring more than one camera if you can, and take several pictures. The graveyard is large enough that you can easily spend several days exploring the grounds and visiting the many graves and family burial plots. Perhaps the pictures you take will reveal ghostly images. It is said that one of the best areas for taking pictures is in one of the older sections nearest the South Street entrance. However, besides spirited images, there is also said to be a very real ghost that is often seen in the cemetery as well.

For many years the locals have spoken of two glowing gravestones in the vicinity of the pond in the graveyard. These two stones are said to glow eerily late at night, seemingly without any logical or scientific cause. Other stones in the same area do not glow. The streetlights are said to be at such an angle that they do not reflect off of these glowing stones. It is said that if you stand on the highest part of the hill in the graveyard, you can't miss this phenomenon. What could cause this unearthly luminosity? Some people claim to have witnessed the apparition of a dark figure standing behind these glowing stones. Could it be the lost soul of Ruth Blay and will she ever be at rest? To this day there is no visible indication of where Ruth is buried, but do these stones glow as a ghostly reminder of Ruth's unfortunate story? What other tales may yet be told from this peaceful resting place?

THE GHOSTLY HUNTSMAN

Even Portsmouth's short side streets have their own stories to tell. Penhallow Street connects State Street to Daniel Street and has a most intriguing tale to reveal. The street takes its name from an early settler named Samuel Penhallow who came over to New England in 1686, and eventually came to call Portsmouth his home. At one time, Samuel became the largest landowner in the colonies. He received an inheritance from his wife's family, the Cutts, who were wealthy Indian traders. The street's name was changed to Ark Lane for some time, because one of the street's residents continually made additions to his house, which came to resemble Noah's Ark. After the man's passing, the house was torn down and the name of the street was changed back to Penhallow Street.

The street was once home to the Portsmouth police station and the Customs House, which operated from 1815 through the 1860s. The Sheafe Street Inn, which stands at the corner of Penhallow and Sheafe Streets, is a brick building dating from approximately 1815. The Sheafes were a very prominent Portsmouth family and they owned many merchant ships that traded goods around the world. The building served as the Sheafe Street Inn and Tavern in the mid- to late eighteenth century. From all accounts, this tavern was visited mainly by the sailors in town. At the time, between ten and fifteen thousand sailors came into port every single week. Stories persisted that men were unable to bring bottles of alcohol into their rooms. The moment a man stepped over the threshold, the bottles would be knocked out of his hands and fall to the ground. Some men even claimed to be thrown down and pinned to the ground by some unseen force when walking past the tavern.

The building was eventually converted into apartments and the old tavern is now a bakery. Employees of the bakery have commented that they close shop for the evening and arrive the next morning to find drawers open and sometimes empty. Pots and pans that were suspended on racks above workstations are often found on the floor—or are sometimes not

found at all. An anonymous employee claimed that throughout the 1990s, utensils would move about the kitchen on their own, sometimes just throwing themselves on the floor. Other accounts even claim that shadowy figures have been seen darting around in the far corners of the kitchen. Feelings of being shadowed are echoed by a few people who work in the bakery, although it is felt that the activity isn't fearsome.

One woman who lived in the first floor of the building a few years ago claimed that she had to move out after an unearthly experience in the kitchen. She said that she was preparing dinner when her kitchen cabinets swung open and dishes started flying out of the cabinets. Canned food also flew out of the cabinets. Running from room to room, she noticed that the only disturbance was in the kitchen. She ran out the door, leaving it wide open behind her, and ran to a friend's house and explained what happened. Upon their return the disturbance was over, but she decided that she couldn't stay there. Within the week she had moved out of the apartment.

Another strange story involves a gentleman who encountered a most unusual apparition as he was making his way down Penhallow Street one very quiet night. As the man walked alone across the street from the Sheafe Street Inn and Tavern, he heard sounds behind him that stopped him dead in his tracks. The commotion heralded an unexpected sight. He claimed to have seen a man on a horse; the man appeared to be dressed for the hunt, complete with a cutlass at his side. Surrounding the huntsman was a large group of dogs, ready for the pursuit. The man stood aside, nearly invisible to the huntsman, and watched him make his determined way down Penhallow Street, then turn onto Daniel Street, toward Market Square. He was so certain of what he had seen that he relayed every detail of the encounter to his associates, who thought perhaps he had spent a little too much time in a local tavern.

A short time later, renovations began in one of the units of the Sheafe Street Inn. A wall that was opened up next to a closet yielded quite a surprise. Inside was the very same huntsman's uniform that the man described on that late night—exact down to the smallest detail that was well over one hundred years old. After the uniform was discovered, more encounters with the apparition of the ghostly huntsman have taken place in the apartments in the Sheafe Street Inn. His true identity has yet to be revealed, but he does make his presence known in many ways. When visiting Portsmouth, be sure to make a journey down some of the small connecting side streets, because you never know who you'll find riding behind you, perhaps on his way to the hunt.

SPECTERS AND MYSTERIES
OF COURT STREET

Court Street in Portsmouth took its name from the courthouse that used to stand on the corner of its junction with Pleasant Street. The street connects beautiful Haymarket Square with Marcy Street and welcomes visitors with many beautiful eighteenth- and nineteenth-century homes. Sightseers may not realize what lies beneath their feet as they make their way down the brick-lined sidewalks illuminated by Victorian streetlamps. Court Street made national headlines in 2003 when excavation for new sewer lines revealed an amazing find. Thirteen graves were unearthed. What had been rumored to be an African American burying ground dating from 1705 was finally confirmed. Eight coffins were moved to the New Hampshire State Department of Archeology. This burial ground is said to be the largest of its kind in the United States and is rumored to be the final resting place for over two hundred people of African descent. The grounds were used through the 1790s, but as land was purchased and developed, at some point it was closed over, used as a roadway and later paved. Discussion and controversy on what to do with the area remains today, as numerous options—from closing off the area to traffic to moving the remains—have been suggested.

You will also find the Parsonage on State Street, a wooden, two-story green house dating from 1749. Strangely enough, it survived Portsmouth's devastating Great Fire of 1813, which happened just feet from the building at the site of the Unitarian Universalist church. Currently the building is used as legal offices, and aside from the plaque on the side of the house, it appears to blend in with many of the other historic buildings. However, for many years it was connected to dozens of homes in town, as it was part of the Underground Railroad network, which helped slaves find their way to freedom. It is in this house I was told the story of the room's existence, although it no longer is accessible because it has been walled off.

The Underground Railroad was in operation from the early 1800s through the mid-1800s. This network of safe houses in Portsmouth was a

Stunning architecture is around every Portsmouth corner.

stop for many slaves fleeing to Canada. Oddly enough, in the early eighteenth century there are many documented cases of slaves in Portsmouth. Many wealthy families had slaves for a variety of labor and trades.

One woman who works in the building relayed stories of feeling an unhappy spirit—the spirit of someone who often stands behind her and her coworker while they are sitting at their desks. She claimed that she often preferred not to be alone in the house, although she said she wasn't actually scared, but rather unsettled about the spirited soul. She believed that this spirit was that of a woman murdered in the house by her husband during the 1920s. I was told that the husband was having an affair and his wife confronted him and demanded that it come to an end. One night the husband came home and shot his wife and left town with his mistress, never to be seen again—leaving the crime unpunished. These women believe that the spirit they are encountering is that of the murdered wife, and that is why they are feeling this sadness and what they sometimes describe as rage. Often doors slam loudly. This is followed by loud banging as if someone is storming up the stairs angrily. The woman said although she feels the hair on the back of her neck stand up, she can understand why the spirit is angry, but she feels the anger is not directed at anyone other than the spirit's murderous husband.

On this street there is a beautiful and stately home with an incredible iron fence and ornate gate and a gorgeous wooden door. The house is flanked by tall columns and is a fine example of classical Roman architecture dating from the early nineteenth century. The iron fence and gate are quite remarkable, as many homes only have remnants of their ironwork left. There is an ornate gate, complete with an iron doorknob, along the fence. During World War II, Americans were asked to salvage iron and metal to help the war efforts. Those who did not donate their fences and gates were looked at as being unpatriotic or unsupportive of the war.

The tour group usually stops under a beautiful black walnut tree that stands in the tiny courtyard of the house. One night while conducting a tour that was later shown on the Travel Channel as part of the show *Destination New England*, a mystery light was seen shining from this beautiful house. I was addressing the group with my back to the house, and the moment I began telling a story everyone seemed to be paying particularly close attention. The moment the story was over, someone in the crowd shouted, "Did you see that?" I turned around to see nothing, but others in the group, including the Travel Channel producers, claimed that they saw this light turn off and on behind me

coinciding with the telling of the story. What was odd was that the part of the house they pointed out was not occupied. You could look right in the windows and see ladders and cans of paint, nothing more. Some folks decided to take a closer look in the windows and some went around the back of the house. There was no activity at the house; no other lights or sounds and not a soul could be found. This particular segment was part of the show that aired on the Travel Channel and to this day it seems to be an odd coincidence—or perhaps the house has an undiscovered haunting. In addition, each time I recount this tale while standing underneath the black walnut tree, one lone walnut will fall with a loud thud and startle many tour guests. The walnut often makes its way home in someone's pocket as a souvenir.

Court Street is also home to the beautiful and elegant Sise Inn in the heart of Haymarket Square. Boasting thirty-four finely appointed rooms, this stunning blue Queen Anne Victorian–style mansion was built by a wealthy businessman, John Sise, in 1881 as a wedding present for his wife. The building served as a residence until the 1930s and became many things over the years. The location served as a doctor's office, beauty salon, upscale dress shop and a halfway house (which some locals have referred to as a mental institution). The building was renovated and made into an inn in the early 1980s. The rooms of the inn are bright and welcoming and some rooms even have finely crafted fireplaces original to the nineteenth century home. Around back is the attractive carriage house, which also has two guest rooms.

The legend is that John Sise had fallen in love with the maid of the house, and although he wanted to continue the affair, the maid insisted that he leave his wife for her. It is alleged that he killed the maid and then hanged himself in what is now room 204, but there are no facts to substantiate that story. Another version of the tale states that the butler of the house was in love with the maid and when their relationship ended he killed the maid and hanged himself in room 204. This tale cannot be authenticated, either. Oddly enough, just two houses down Court Street from the Sise Inn there was a well-documented murder-suicide of a husband and wife in 1905. Also in 1916 there was the unsolved murder of George Stillson, who was clubbed to death mere feet from the Sise Inn. The inn is said to be haunted by two distinctly different ghosts. Their identities are uncertain.

Much of the ghostly activity takes place in what is now room 204, although other incidents happen throughout the mansion. Women in

room 204 have often commented that they felt someone pinch them, yet when they looked around they found no one there. There have been instances where guests in the room have woken up to find footprints that did not belong to them impressed into the carpet surrounding the bed, as if someone had been standing over the bed all night long. Indentations have also been found in the bedclothes and mattress, as if an unseen person had sat down on the bed. It is also rumored that the Sise Inn keeps extra keys to the room for a most bizarre reason. People who have checked out of the room believing that they left the key behind have claimed to have opened their luggage upon arrival home only to find the key. Room keys for room 204 routinely turn up in the mail.

One young couple was returning from a late night out and went back to their room, 204. Upon trying their key in the lock, they found the keyhole blocked, as if the key was being pushed out from the other side. After trying several times to unlock the door, they brought back a member of the inn staff to try the master key in the lock. The master key did not work either. Because there were no other available rooms in the inn a call was made to a twenty-four-hour locksmith, who arrived at 4:30 in the morning. According to the tale, the locksmith was handed the key from the room guests, and on the first try, the locksmith was able to turn the key and unlock the door without doing anything but putting the key in the lock. Some folks like to say that perhaps the ghosts wanted to have a little alone time in the room.

There have also been times when the ice machine on the third floor has turned itself on and guests in room 204 were awakened by a tapping on their door, only to find a pile of ice cubes in their threshold and a trail of ice leading down the hall. Late-night searches by inn staff revealed no source for the disturbance during these quiet hours when everyone was asleep. In some instances these ice incidents occurred when there were no guests on the floor, and the sound of the machine attracted the employees up to investigate, only to discover no one around.

The rocking chair on the first floor near the check-in desk is said to oftentimes rock by itself. One clerk described an unnerving moment in the house. He claimed that he was the only one on the first floor, and he walked out from behind the counter and across the room. He described hearing a scraping sound coming from behind the desk. He whirled around and looked to find the source of the sound, and all he found was an open drawer in the desk and a pair of large scissors sitting on the

The Sise Inn is located in beautiful Haymarket Square on Court Street.

counter. It is said that he grabbed the scissors and threw them back into the drawer and didn't speak about the incident for some time, uncertain of what he experienced.

This wonderfully appointed inn also has an elevator, which is rumored to go up and down at will. No one gets off or on, yet the buttons have been pushed. Doors to the rooms have been locked and mysteriously unlocked with no reasoning. A potted plant is said to have flown across one room, prompting the guest to request another room. One maid claimed that she felt the arms of some unseen entity around her pulling her into a closet. Another maid claimed she felt someone put their hands on her hips when she was bent over cleaning in a room, and yet when she turned around there was no one around.

The ghosts are believed to be one male and one female spirit and spectral stories have been told since the days when it was a halfway house. Should you happen to stop by the Sise Inn, you will find that the owners prefer not to discuss the inn's haunted history. In that case, you may want to book a room and decide for yourself.

JOHN PAUL JONES HOUSE

On the corner of State and Middle Streets in Portsmouth you will find the John Paul Jones House. The yellow three-story home was built in 1758 and is a glorious example of Georgian architecture, complete with a gambrel roof. The colorful period gardens that surround the house are a delight to the eye when in bloom. It's unbelievable to think that this stately house, once featured in a Sears paint commercial, was scheduled for demolition back in 1919.

Many Portsmouth historic buildings and properties have at one time been at risk for destruction and redevelopment, but thanks to the newly formed Portsmouth Historical Society, this house was saved in 1920. The society opened Portsmouth's first museum here, and today it conducts tours of the home filled with priceless antiques. The collection features local Piscataqua furniture, a large display of eighteenth-century leather fire buckets, fragile period attire and dresses, an assortment of walking sticks owned by the locally famous, imported ceramics and historic weapons.

Ship Captain Gregory Purcell built the lavish home for his bride, Sarah Wentworth, the niece of New Hampshire's British colonial governor, Benning Wentworth. When Captain Purcell died in 1776, his widow Sarah accepted boarders to help maintain the costs of owning the house and raising eight children. One of the boarders who stayed at the house was none other than John Paul Jones in 1777.

John Paul Jones came to Portsmouth a fascinating man with intense spirit. His brief stay in the city was to oversee the building of the ships the *America* and the *Ranger*. There was a bit of controversy in Jones's past, and some even accused him of piracy. It is true that Jones did captain many slave ships and he was accused of murdering a shipmate. An insubordinate and threatening shipmate was about to cause a mutiny and left Jones no other choice but to take action. Sometimes he was referred to as a privateer, as he had obtained many merchant ships on his expeditions, but there was much more to Jones than met the eye.

The John Paul Jones House is preserved by the Portsmouth Historical Society.

Jones is hailed as the father of the American navy and his famous exclamation, "I have not yet begun to fight"—uttered when asked for surrender on the sea—has become part of history books. In addition, his charming disposition, dashing good looks and Scottish ancestry left quite an impression on the locals who met him during his short stay in Portsmouth. Local legends declare that the women of Portsmouth were so enamored by the attractive Jones that one day the local ladies' quilting circle got together to make a special gift for the captain. It is said that these women took swatches of material from their finest Sunday gowns and quilted them together to make Jones a flag to fly on one of his ships. Even if the tale is simply legend, there is no doubt that Jones often had the entire town in an uproar, sometimes sending social gatherings late into the night.

John Paul Jones's life was ambitious, fascinating and highlighted by numerous successes at sea all over the world. He was a very close friend of Benjamin Franklin and during those years, Jones played a vital role in the American Revolution. Jones had hoped to convince Congress that he should be appointed as the United States Navy's first admiral, but it was never to be. Jones served a short but victorious time in the Russian navy, and his last days were spent in Paris, France. In the end, Jones was penniless. He died in 1792 from an extended illness at the age of forty-five. It is said that Jones believed that some of the happiest days of his life were spent in Portsmouth.

Jones was buried by the French in an inexpensive coffin, with little pomp and circumstance. It wasn't until 1905 that President Theodore Roosevelt decided to bring back his body from France to give Jones an honorable and distinguished burial. When Jones was exhumed after an exhaustive and often misled search, his body was mummified and quite fleshy. His remains were returned to Annapolis, Maryland, for a prestigious ceremony presided over by Roosevelt himself. It was there that Jones's journey finally seemed to come to an end—but did it?

Unexplained activities at the John Paul Jones House prompted a couple of investigations to look into what—or who—was causing disturbances in the home. It is alleged that psychic investigators went through the house in the early 1980s and they came to the conclusion that the spirit of John Paul Jones was in the house. Was it Jones who was causing display cabinets to unlock and lock on their own? Could it have been Jones who mysteriously moved antiques to different areas of the house, rearranging them to his own taste? In a few instances, while groups were touring the

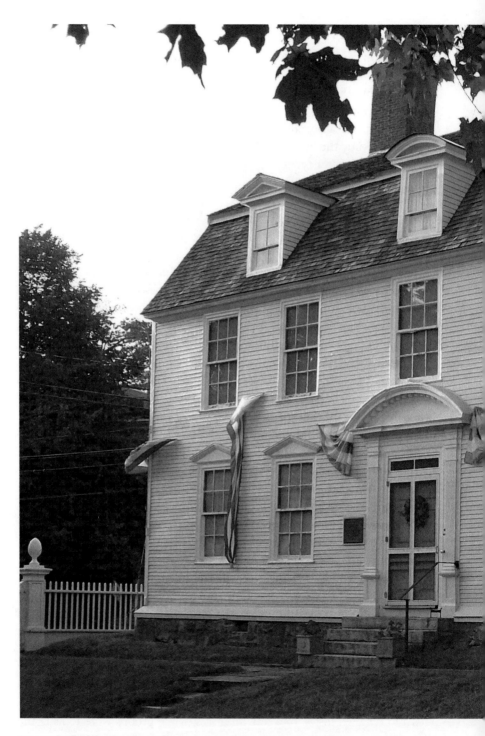

The beautiful John Paul Jones House has been featured in a television commercial.

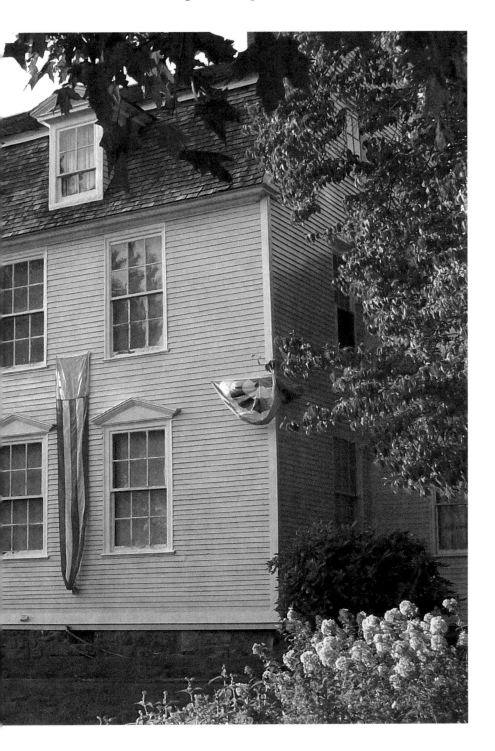

outside gardens, the door to the house would close and lock from the inside, for no particular reason.

According to a more recent tale, police were called at night to investigate strange noises coming from the attic, only to conclude that the sounds were probably coming from bats. Perhaps the source of the haunted activity isn't Jones; maybe it is linked to some of the antiques in the Historical Society's collection.

Another legend of the house has to do with two marble cherub statues. The statues are not original to the house. They came from a house in the Plains section of town during the eighteenth century. They are said to have stood on the parapet over the doorway to the home of Ursula Cutts.

The story goes that Indian attacks on the outskirts of Portsmouth were quite prevalent in the town's early days, due to the fact that the properties were rather isolated. It is said that one afternoon in 1694, Mrs. Cutts observed the Indians sweeping across her fields, ready for the attack. As she tried to make way toward her house with her servant at her side, she hoped she could barricade herself in. Unfortunately, as soon as she approached the house, she was ambushed by the Indians. The servant was mercilessly and brutally scalped in front of Mrs. Cutts. Before the Indians scalped Mrs. Cutts, they saw the rings on her fingers and they savagely chopped off her hands before scalping her and leaving her for dead. All of this is said to have happened in the shadow of the two marble cherub statues that stood over her doorway. If only she had been able to lock herself safely inside, this story may have had a different ending.

Many locals have said that late at night you can see the face of a woman with a white face of marble peering from the windows of the John Paul Jones House. She is said to be staring out the windows as if on the lookout for something or someone.

When you visit the John Paul Jones House, you will find the embodiment of Jones on the second floor of the house. Seated at a desk is a life-sized figure of Jones completely in uniform, which can be a little startling when first stepping into the room. Even more shocking is the photograph on the wall of Jones's mummified body. So, how intimidating could the spirit of John Paul Jones be? The house is certainly worth a visit. Return to the days of the ships the *America* and the *Ranger* and unveil the story of the captivating Scotsman who briefly called Portsmouth home.

FRANK JONES AND
THE ROCKINGHAM HOTEL

Frank Jones is one of the most intriguing and influential people in Portsmouth's history, yet so many people haven't any idea who he was. Certainly some people are familiar with the Frank Jones Convention Center on Lafayette Road, but this modern building bears no relation to his dynamic and sometimes eccentric legacy. To find the real Frank Jones, pay a visit to the old Rockingham Hotel on State Street. There you will find the essence of Frank Jones and all of his glory.

Frank Jones was born in Barrington, New Hampshire, in 1832. He grew up on his family's farm and moved to Portsmouth when he was sixteen. Frank showed that he had the genius to become an extremely successful self-made businessman. He started out in his brother Hiram's stove business, and his entrepreneurial spirit showed early on. Frank soon bought out his brother's enterprise and he made important business contacts through this successful venture. A few years later, his brother Hiram committed suicide by slitting his own throat in the privy on the farm in Barrington. Frank then married his brother's wife and took in their daughter Emma as his own.

Frank had another brother who, shortly after a debilitating fall from a roof, committed suicide by hanging himself in the family barn. Frank pressed on, making quite a future for himself. Several business ventures were undertaken by Jones, including ownership of the Portsmouth Button Factory and the Shoe Factory, one of the largest factories in New England at the time. He also became president of the Boston and Maine Railroad and opened a successful insurance company.

Frank Jones had impressive success as a brewery owner. He owned the largest and most successful brewery on the East Coast in the late 1800s, and this distinction earned him the title of "King of All Ale Makers." His enormous brewery with over fifty buildings was located on Islington Street in Portsmouth, and many of the buildings still stand today. At its height, the brewery was manufacturing six hundred thousand barrels

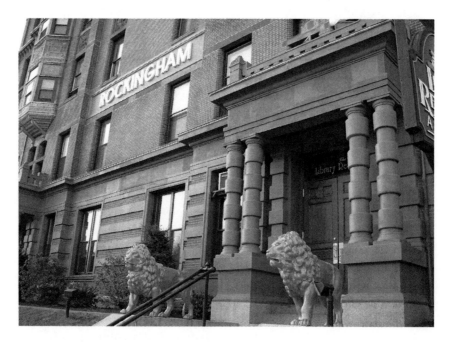

The fascinating Rockingham House was formerly an elegant hotel.

of ale each year. This volume caused Frank Jones to build many other structures in town—from housing for the brewery workers, to waterfront warehouses used to store ale for shipment by boat. Frank installed a city water system to pipe in clean water for his breweries. Remnants of this system are occasionally dug up by the public works department. He also maintained private wells for his brewery.

In addition, Frank Jones was mayor of Portsmouth for two terms. He ran for governor of the state of New Hampshire and lost by only two thousand votes. As if those accomplishments weren't enough, Frank Jones was also a Congressman for several terms. These ventures afforded him the opportunity to build and purchase property throughout Portsmouth and the surrounding areas. One of his purchases was the beautiful Wentworth By The Sea in New Castle, one of New Hampshire's grand golden-era hotels. Frank enlarged the hotel to enormous proportions and had its distinctive towers constructed. The Wentworth was recently restored to the tune of $25 million after being abandoned for over twenty years, and it was brought back to the era of Frank Jones, a time when it was the most opulent.

Jones also built himself a miniature version of the Wentworth By The Sea at the junction of Woodbury and Maplewood Ave in Portsmouth. The beautiful home once stood on an eight-thousand-acre estate, and is about a mile and a half from the Rockingham Hotel on State Street. The estate has been extensively developed over the years and the home has been converted into apartments, although it did serve as a sanitarium for some years. One reason to take note of the location is that Frank used the property as one of his summer homes. He spent winters at his beloved Rockingham. Legend tells us that Frank used to travel between properties in a most unusual way. It is said that he would travel by horse and carriage through a large underground tunnel—with a span of a mile and a half—that ran from the Rockingham Hotel to the Maplewood estate, underneath what is now Maplewood Avenue. By all accounts the tunnel has collapsed by now, but I have heard from some people that while doing excavation in their backyards, parts of the old tunnel were actually dug up.

The original Rockingham Hotel owned by Woodbury Langdon—elder brother of John Langdon, former New Hampshire governor and United States senator—was acquired and remodeled by Frank Jones in the 1870s. Frank was very interested in hotel ventures due to the numerous businessmen who came to town to have dealings with him. He wanted people to be impressed with their visit to Portsmouth, so he decided to build a showpiece that did far more than just impress the dignitaries that came to town. The Rockingham became known as one of the grandest establishments in New England.

In 1884, the structure suffered a severe fire, which nearly destroyed the entire property. Frank Jones arranged for immediate reconstruction to begin after the fire and no expense was spared in the efforts. The very extensive wooden panels throughout the Rockingham are hand-carved Spanish mahogany, done by skilled Hungarian woodcarvers. The chandeliers were made by Shreve, Crump and Lowe of Boston, one of New England's oldest jewelers, and are encrusted with large opals and semiprecious stones. The floors are made of imported Italian marble, and there are numerous ornate fireplaces throughout the building. Frank Jones was also a horseman and many of the fireplaces are adorned with large brass horseshoes designed to be symbols of luck.

There is much symbolism and superstition built into this amazing building. Standing guard at both entrances to the Rockingham are two golden, cast-iron lions. They were thought to be a symbol of protection from all of the evils of

The Rockingham House is magnificent.

the world for anyone who was a guest at the Rockingham. When looking at the front of the building, you can't help but notice who is looking back at you, as there are six faces in the façade of the building. At the top of the building on each end are two triangular peaks, each of which contains a hand-carved face in terra cotta. The three-dimensional face on the left is that of Woodbury Langdon, the original owner of the Rockingham, and on the right is the face of Frank Jones. When you look below the second row of windows from the top of the building, you will notice four more faces. From left to right are the faces of a young boy as he ages and becomes an older man. These carved images are known as the four seasons of man, and it is said that Frank Jones thought these to be the four very important stages of growth and development during a man's life. These faces are most dramatic when evening shadows are cast upon the building, and they then take on life of their own. In 2005, the building underwent a detailed face-lift to the façade of the building in which they cleaned the brickwork, reinstalled the Rockingham sign and cleaned the terra cotta at the cost of one million dollars.

Frank Jones passed away on October 3, 1902, but his legacy lives on throughout Portsmouth, in other places besides the Rockingham. In the Harmony Grove Burial Ground, part of the South Cemetery, stands the Frank Jones grave. He had it built shortly before his death, and it stands as the tallest grave marker in the state of New Hampshire, at twenty-eight feet high. Also, there is another Frank Jones tunnel that is said to still exist underneath Bow Street, where the old brewery warehouses have been converted into commercial and residential spaces. There is a warehouse building connected to St. John's Church on the hill by an underground tunnel that goes underneath Bow Street. The legend is that Frank Jones used to pay the church two dollars a year to maintain a basement room in secret that was designed to store between sixty and eighty barrels worth of ale. As recently as the 1950s, the tunnel was open and in good condition. I spoke to a gentleman who was a Boy Scout back then and he said that they kept their gear and supplies in the tunnel. The scouts used to like to dare each other to run down to the other end of the darkened tunnel; however, I was told that many of them were too afraid to run down into the darkness. I have heard that the tunnel was sealed off, but may still exist in good condition.

The Rockingham Hotel was finally converted into condominiums when the building fell upon hard financial times in the early 1970s. There are currently twenty-five units in the main building, as well as the Library Restaurant that opened in 1975. In fact, the large, curved marble bar in the restaurant was the original reception counter for the first Rockingham Hotel. The units are remarkably preserved to their original nineteenth-century splendor. Many units still have their original hand-painted ceiling frescos, some displaying gorgeous angels and exotic flowers. There is quite a legend behind these colorful murals. In the evenings when business discussions were over, Frank Jones would often invite ladies from Portsmouth's infamous red light district back to the Rockingham to entertain his guests. The well-documented legend about the paintings on the ceilings is that they were painted there to give the ladies something to look at while they entertained the gentlemen. Coincidentally, Frank Jones rented property to the notorious Gloucester House, a house of ill repute that was known as far away as Asia for having beautiful and skilled ladies.

One of the first residents in the Rockingham House after the condo conversion was Esther Buffler, a local poet laureate and history buff. During Esther's first weeks in the building, she kept having encounters

with a mysterious woman. Esther described her as a woman with long black hair with sweeping gray streaks. The woman wore a beautiful cameo around her neck. At first, Esther thought that the woman was looking to purchase a condominium herself, but when she saw her disappear into the wall, she realized that this woman was a visitor from the spirit world. Esther called her "the night woman." She also became known as the "White Lady of the Rockingham" because of her long, graceful, white gown. Esther said she didn't know who the woman was or why she chose to wander the halls of the Rockingham, but she became so enchanted with her that she soon penned the poem "The White Lady of the Rockingham" in her honor. For years Esther said the woman continued to visit her and always disappeared into doorways and walls. There were even suggestions that late night sounds coming from an empty condominium unit were caused by the Lady.

Other accounts say that the mystery woman is also known as "the lady who smells like the sea." If the woman truly has a connection to the sea, perhaps she came to Portsmouth by ship. I regularly visit the property with my tours and on some occasions, a guest will comment on smelling the sea—before the tale is even told. It is important to note that the building is not located anywhere near the water.

There are some theories as to who this "night woman" may be. Some people believe that she comes from the nearby Music Hall. Frank Jones had purchased the Music Hall in 1901 because he had a young lady friend who wanted to be an opera singer. Other people suppose that she is a lost soul from the red light district. With those thoughts in mind I always like to draw the following parallel. Oftentimes unsuccessful shows would close early at the Music Hall and the girls who were part of the performance would end up working in the red light district to earn enough money to obtain a train ticket home.

Many famous dignitaries, movie stars and notable people have either stayed at or visited the Rockingham over the years, including Mark Twain, Ulysses Grant, President Chester Arthur, author Oliver Wendell Holmes and many others. The Rockingham is a remarkable piece of history, dazzling to look at and a feast for the imagination. Did Esther's mind's eye envision the night woman, or has she taken up permanent residence at this famously historic location?

THE DARKER PAST OF
111 STATE STREET

Not all ghostly activity is of the good-natured, playful variety; some encounters feel malevolent and downright evil. One brick building, 111 State Street, dates from approximately 1814 and was built on the foundation of a structure claimed by the Great Fire of 1813. Throughout the years it was the location of many businesses, including a brothel—during the late nineteenth century—and a shoe store. All seemed a bit quiet until the past twenty-five years, and things haven't been the same since.

During the 1980s, one part of the building was occupied by the bistro Café Petronella, a terrific place for creative souls. The other business in the building was Wally's, an area biker bar. The juxtaposition of the two businesses was quite interesting, but it seemed to work. Café Petronella was a place of arts and culture with a European flair. The owner himself, William Frank, was explorer of the four corners of the earth. An inspiring and accomplished landscape painter, Frank wanted to promote a place of culture and the arts. Often there were art exhibits from exotic places, and live music was played alongside elegant fashion shows, which helped to differentiate the bistro from others in town.

Wally's had its own style and culture, too. However, instead of art exhibits there was a line of motorcycles, with fantastic murals and paint schemes, parked out front. The music may have been a little more on the rock-and-roll side, and instead of fashion shows, there were wet t-shirt contests. Wally's was often in the newspapers because of local fundraising motorcycle rides that ended up there. People watched the spectacle from the sidewalks as bikes arrived one after another, often with American flags waving in the breeze.

After about a dozen or so years, the owner of Café Petronella decided that it was time to retire from the business, so the quaint artist's hangout was no more. The new business, appropriately named the Old Bridge Café, took its

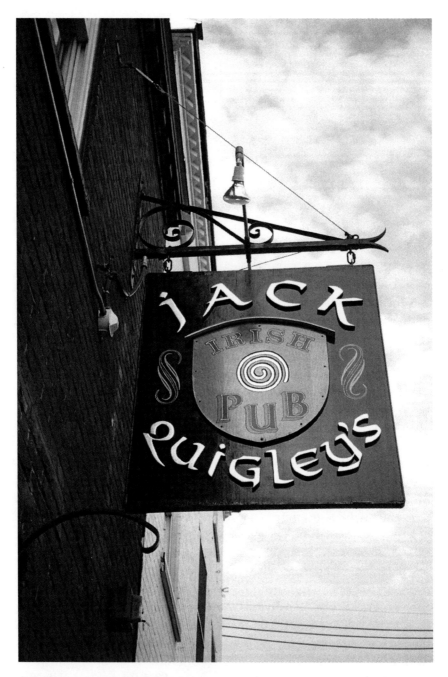

This historic building has undergone many transformations. In 2006, it transformed from an Irish pub, Jack Quigley's, to a sports bar.

name from the proximity to the oldest of three bridges connecting Portsmouth to Kittery, Maine. The World War I Memorial Bridge was opened for use in 1923. Newspaper and court records mention that almost on a daily basis you could hear mention of the café during someone's arraignment. Apparently the place attracted the type of clientele prone to creating disturbances—such as being drunk and disorderly, committing assault or using drugs—and arrests were commonplace.

It is said that the upstairs dance floor at the café was so out of control that some locals told me that "good girls" didn't ever go there. Documented newspaper records show that people openly did drugs while dancing, and sometimes passed out. Because of the unhealthy and lewd acts in the ladies' bathroom, the door was removed. I have even heard that some bathroom stalls didn't have doors and that patrons could look right into the room.

In August of 1996, the Old Bridge was the scene of a disappearance of a young city woman. She was last seen at the café in the company of a man she had only known a short time. There has been some conjecture as to whether she left the café willingly with this man and his friend, or if she was drugged and taken out against her will. For nearly a year and a half, her body was not found, despite exhaustive searches by authorities. Her remains were finally discovered in a makeshift grave next to a highway, miles away in Lincoln, New Hampshire. The coroner's ruling was that she drowned. The story unraveled in court that she was brought down to the waterfront and drowned in the Piscataqua River. The two men she was seen leaving the café with were arrested for her murder. They were also suspects in other unsolved murders. They were eventually convicted and are now serving long sentences in a New Hampshire state prison.

A September of 1998 newspaper story reported a family riot at the café, and a number of New Hampshire state troopers were called in. Backup from surrounding communities was also called in. The family disturbance spilled out onto the street and a large, unruly crowd gathered, preventing police from getting the incident under control. In the end, three people were arrested and a police cruiser was severely damaged.

December of 1999 brought the police back to the Old Bridge Café. Soon thereafter, a jury, brought to the location to investigate another murder, also made its way to the café. A thirty-four-year-old man was stabbed in the heart after meeting a friend at the café, and his body was found lying in the street just around the corner. When the police arrived that night, they knew that he had been in the Old Bridge, so they

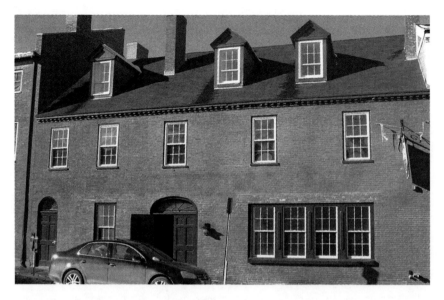

Once devastated by the Great Fire of 1813, brick buildings like this one on 111 State Street are now commonplace.

proceeded to question the patrons inside. While everyone agreed that the man was in the bar, there were no answers as to how he ended up dead. The police closed down the bar—with approximately thirty patrons inside—until 5:30 in the morning. All the while the body remained in the street, which was by then roped off as a crime scene.

The man's friend later pled guilty to manslaughter, claiming that he was under the influence of hallucinogenic mushrooms and other illegal drugs. In his plea, he stated that they had left the bar and gone back to his boat to do drugs. They then returned to the bar and argued over the drugs. A fishing knife was brandished and the crime was committed. Moments later the body turned up around the corner on Chapel Street. Some people I've spoken with claim that the bartender at the Old Bridge was someone you wouldn't cross and that he may have known more than he was saying. One frequent patron even claimed that the bartender might have witnessed the stabbing.

The police seemed to visit the café on a fairly regular basis and eventually the business was shut down. Enter entrepreneur Jay Smith. A man with his own vision for the property, his objective was historic preservation. Jay had already owned the Press Room in Portsmouth, a local favorite haunt for many who loved the live music played there seven

nights a week. He was a local philanthropist and was instrumental in saving the Music Hall during the 1980s when its fate was most uncertain. He also owned buildings around the site, so his interest in this historic property seemed natural.

Smith purchased the building and leased it to a gentleman who had ambitious intentions of opening the property up as an authentic Irish pub. Jay decided to combine the two buildings and renovate the property to make it attractive and highlight its historical features. In 2001, Jack Quigley's opened up. It was styled after authentic Irish pubs. Finally, things seemed to be looking up.

Sadly, almost a year to the day after purchasing the property at 111 State Street, Jay Smith unexpectedly passed away at the time of Jack Quigley's grand opening. Just a very brief walk from the door to the building is a small pocket garden dedicated by local citizens to Jay's memory. The beautiful roses that grow there surround a simple marker to Jay Smith.

The restaurant was beautifully designed with dark woods and comfortable seating and could hold over three hundred patrons. The colorful Celtic knot stained-glass window in the entryway was a wonderful detail, as was the snug on the first floor. The snug was a wonderful place to bring tour groups, as it had fantastic roots to colonial times. When the patrons in the pub got a little loud cheering for the Red Sox or the Patriots, I simply closed the door and we were in our own little world.

Snugs were secret places in American taverns that allowed women to drink unnoticed. Ladies were forbidden from visiting taverns, but many tavern keepers knew that women could be just as good customers as their male counterparts, so they had these rooms specially designed. Often these rooms appeared to be closets or storerooms. They had their own private entrance so that women could come and go completely unnoticed. The rooms were often built underneath staircases and sat about twelve women. The snug at Jack Quigley's was quite cozy, and although it didn't have a hidden door, it did have a beautiful wooden door with a Gothic arch window.

The property soon changed hands. It remained open as Jack Quigley's and hair-raising stories were now relayed by the staff. The new owners also maintained another area Irish pub, and due to that commitment were not at Jack Quigley's often. Some locals said that more beer went out the back door than what was served to the patrons. The waitresses who worked there were eager to tell their tales of ghostly encounters.

The second floor of the restaurant was only open on Friday and Saturday nights, so most of the time there was no one up there—or was there? Several of the waitresses I interviewed told me that when they went up to the second floor they felt someone else up there with them. Unnerved by the sensation of this unseen spirit, they did what they liked to call a "drop and run." Whenever they had to go up to the third-floor offices or pass through the second floor, they would literally run so that they weren't confronted by this entity. Some of the staff completely refused to go to the upper floors because they were convinced that there was something evil up there.

The bartender at Jack's described startling incidents on the second floor. He said that on quiet afternoons when the upstairs was closed, you could hear scraping sounds across the ceiling. When a few brave souls went up to investigate, they would find the barstools that normally stood around the bar scattered around the floor. The bartender described an occasion when this scraping went one step further. After hearing the stools dragged across the floor, the sounds were followed by a very loud series of bangs that resonated through the downstairs ceiling. A group of employees ran upstairs to investigate and they were stopped cold in their tracks by the sight before them. Each and every barstool was upended and placed upside down all around the bar. Everyone who witnessed this phenomenon was certain that no one had been upstairs. The large metal door to the stairwell had been completely closed all afternoon.

Another waitress nervously relayed a terrifying story from the second floor. She said that she was on a drop and run mission to the third floor when she passed by the large beer mirrors hanging on the second-floor walls. When she caught a glimpse of her reflection in the mirror, she saw the face of a man reflected right next to hers. She looked around and saw no one else in the room. Frightened by what she described as a horrible face, she shrieked with fear. Employees on the first floor ran up to find her frozen in place, petrified of what she just experienced. She said that she never wanted to go up there again under any circumstances.

Employees were not only scared of the second floor; one waitress was scared of what she felt in the basement. She felt malevolence down there. She thought that someone was following her around and often asked other employees to retrieve things that she needed from the basement.

During one tour that I brought into Jack Quigley's, one guest had a panic attack inside the restaurant. We sat down in the snug, which wasn't too far from the bar on the first floor. As soon as we got comfortable, this

woman's face got red and she blurted out, "My God, someone's been killed here. I can't stay." She began gasping and made her way quickly to the front door. I followed her outside to make sure that she was going to be all right, and once out on the sidewalk she seemed to calm down a bit. She told me that she knew someone had died violently in there. She didn't know who or when but she said she felt it. After convincing her to return to the tour, we went back into the snug. I relayed the location's dark past and the woman nodded her head in affirmation. For the rest of the tour, this guest seemed a bit unhinged and shaky. When the tour ended, the woman came up to me and said that she knew something followed her from Jack Quigley's that night and she hoped she wouldn't take it home. I was surprised to see an e-mail from her the next day telling me that when she returned to the parking garage, she went to pay for her ticket and the attendant told her that the ticket wasn't working and that it had been demagnetized. According to her, the clerk said that this was the first time that this had ever happened. She said she checked her purse and found nothing that could have caused that to happen. This incident confirmed to her that there was indeed something unearthly happening that night.

On July 3, 2006, the New Hampshire State Liquor Commission shut down Jack Quigley's for good because of violations. They had been cited twice in the past year for the alleged sale of alcohol to intoxicated persons and for the alleged sale of alcohol to minors. When they were cited in July, the Commission found that they were serving alcohol without having renewed their food-serving license. The owner of Jack's decided not to renew the license and the building was sold at auction in August.

The windows were dark and the doors closed for several months. Speculation mounted over what might become of the building. Some people thought that the building might become upscale condominiums, making the location inaccessible to the general public. Then in December, a few lights were seen in the building and contractors' trucks were parked out front. Jack Quigley's was about to undergo yet another metamorphosis.

A new tenant was ready to go ahead with his own vision for the business, and with that the Irish pub was no more. A sports bar theme was chosen. The new property included flat-screen televisions and a brighter and cozier second floor. The first-floor snug was not in the renovation plans and was quickly demolished. In January 2007, the business opened. It was a little more polished than the last one, but would the ghosts of Jack Quigley's still linger?

I decided to lead a few very small tours over to the new property and to introduce ourselves to the new owner. This time, whenever I visited this storied building I brought a digital camera and an Electronic Magnetic Field (EMF) reader. The meter detects changes in energy forms and is a standard tool used by ghost investigators. After introductions were over, the new owner stated that there was something "very bad" in the basement, although he would not let us take a closer look. I noticed that on the second floor the EMF reader got erratic readings, which could be interpreted as paranormal activity. I also took notice that the beer mirror—in which the Jack's waitress saw a man's face—was hanging on the wall just a couple of inches higher than it used to be. I decided to take three pictures with my digital camera. The first image was taken without a flash and was quite a bit out of focus. The second image was clear and sharp and appeared to have an orb in it. The third picture taken from the same spot was most surprising. In the mirror you could clearly see a white, skeletal face with vacant eye sockets and a twisted mouth. The photo was studied for reflections and light flares and yet there didn't seem to be anything that could cause this anomaly. In the previous image there was only a round white circle. Could this phantom spirit have been caught on camera? It really looked that way.

This type of activity may be associated with a poltergeist type of haunting where there is some emotional impression. Poltergeists are thought to make themselves known by moving physical objects in their environment. There are some theories as to who the spirit may be. Some folks think that it is Jay Smith, who had spent so much time at the place and had really hoped to turn things around. Many people believe that the spirit may be connected to the 1999 stabbing that allegedly took place there.

In the summer of 2007 I escorted a tour to 111 State Street. One of my guests paused at the entrance to the location, and slowly said, "You're not going to tell me that there's ghosts here? I just purchased this building last summer!" I was surprised to find that the owner of this interesting spot somehow found his way onto my tour. While he said that he didn't believe in ghosts, he did confirm that something wasn't quite right in the basement. Even with a new building owner and business owner, AK's—the sports bar and bistro that opened with such promise in January of 2007—closed in February of 2008. Another business is going to try their luck in the summer of 2008, hoping that their vision of a Mexican restaurant will work. It will be interesting to see what becomes of the next business at this ever-changing address. Whether or not you believe in the spirits at 111 State Street, there is no doubt of its well-documented dark past.

Legends of Four Tree Island and the Portsmouth Naval Prison

Crossing the bridge to Pierce Island from Prescott Park along the beautiful waterfront, you will find Four Tree Island connected by a causeway. It's a wonderful place to picnic, with several picnic gazebos and tables throughout the island. The island is mostly surrounded by the Piscataqua River, and you will be entertained by the maritime traffic. From this vantage point you can get a wonderful view of the Portsmouth Naval Shipyard and some of the historic buildings that stand on the property. The island has had many names over the years, including No Tree Island, One Tree Island, Two Tree Island and so on.

From this lookout you can get a great view of the old Portsmouth Naval Prison, which began operations in 1908. The structure really stands out along the skyline and looks like a giant castle. The prison has been abandoned since 1974 and has slowly started to succumb to the elements. It is easy to see that many of the windows are completely gone, and part of one tower has collapsed.

When it was open, the Naval Prison was one of the most feared places in the United States. The standing orders for the guards on duty were to be sure not to let any prisoner escape. If a prisoner did get away, the guard would be forced to serve the remainder of the prisoner's sentence, even if it was for life. There were few escapes made, but all of the prisoners were captured very quickly and they usually didn't get very far. It is surprising that guards were allowed to shoot to kill if an escape attempt was made.

The prison itself is the subject of local legends. The prison was modeled after the infamous Alcatraz, and became known as the Alcatraz of the East. The final scene in the movie *The Last Detail*, starring Randy Quaid and Jack Nicholson, was filmed there in 1973. Throughout its history it is said to have housed over eighty thousand prisoners. One legend is that a prisoner was being escorted to the naval yard when a scuffle ensued with

a naval officer over a pack of cigarettes. The prisoner allegedly raised his handcuffed wrists and violently hit the officer in the face, leaving him scarred for life. That officer was none other than Humphrey Bogart.

As of late winter 2008 plans were put in motion to seek someone who would be interested in leasing the prison property. Perhaps with new visitors there will be more stories told from the shadowed halls of this looming structure.

Four Tree Island has a dark past with which most people are unfamiliar. During the nineteenth century, the island was only accessible by boat and was a bit of a tourist attraction. The proprietor of the property was Charles Gray. He owned the island and constructed a large building that seemed to have everything any visitor to Portsmouth could want. This business was known as the Four Tree Island Museum and Emporium. The museum boasted itself as a museum of oddities, containing strange things from the four corners of the world. These items were often brought back by the many international travelers who came to visit Portsmouth. On display was a pair of cowboy boots said to have been worn by none other than outlaw Jesse James. However, the most interesting item on display was a preserved cow that was rigged up to serve alcohol through its udders. It was in use as the centerpiece of the tavern, which was part of this complex.

There were ladies of ill repute on the island, as well as illegal gambling. The island's owner was not held accountable for any crimes committed because the Portsmouth police commissioner claimed that since it was an island, it was out of his jurisdiction. The activities went unwatched and unmonitored and quite out of control. In fact some referred to it as a "Leper Colony."

When enormous numbers of sailors coming into port heard about this self-proclaimed museum, they fancied an evening there. The island seemed to have everything a man could want. Sailors paid fifty cents for the boat trip to the island. Strangely, there was only one boat that went to the island, and this was operated by the property owner. When the patrons were through enjoying their time on the island they would return to the boat only to find that the return trip was not fifty cents, but five dollars. As a result these men found themselves completely stranded on Four Tree Island.

As you can imagine, at the end of an evening of drinking, some men felt rather brave and made a fateful choice. As they looked at the distance between the waterfront and the island, some men felt that they could swim

right over. This was a deadly decision. Not realizing that the Piscataqua River has the second swiftest current in the country, and that depths reached seventy feet in some places, they put themselves in a perilous situation. During the time the tavern was on the island, newspaper accounts often told stories of bodies washing upriver in the Great Bay or at the mouth of the river where the lighthouse stood. The dead men were always last seen at the tavern and museum on Four Tree Island.

The business lasted about thirty years, and then one day in 1902, a mysterious fire broke out and claimed the buildings and all the goods therein—including the cow. No one was ever convicted for starting the blaze and some people question if there was even an investigation. After the fire, the property was never rebuilt and the island was neglected. Some years later the property changed hands and became a public park. A causeway was built to allow visitors out to the island. People are quite surprised to hear the unusual history of this pretty little picnic spot with a rather seedy past.

SECRETS OF WATER STREET

If you ask for directions to Water Street in Portsmouth, you will find that no one knows its location and it is not on any map. The street name was changed to Marcy Street in 1925, as if to disguise the road's sordid and violent history. Today Marcy Street is well traveled by locals and visitors, as it leads to the beautiful waterfront gardens known as Prescott Park. Marcy Street also leads people to Strawbery Banke, one of the oldest neighborhoods in the country. Strawbery Banke is very much a living history museum with nearly sixty period homes dating as early as the seventeenth century. The costumed role players and restored homes invite visitors back to different eras on the seacoast.

The era of Portsmouth's infamous red light district, which largely occupied Water Street, is rarely revisited. The area now known as Prescott Park was once called Puddle Dock. The name Puddle Dock came from the tidal waters that used to wash in from the Piscataqua River. At low tide, these waters appeared like a large puddle. This was where ships came into dock and offloaded their goods from all around the world. At the time, this area of Portsmouth seemed quite different from the affluent and grand governor's mansions. This was a rough-and-tumble part of town, and although the police commissioner was always in this area, he wasn't necessarily enforcing the law. He was eventually exposed for taking bribes and enjoying the hospitalities of the brothels.

There were more brothels in this part of town than anywhere else. Some say there were upward of twenty houses of ill repute in this very small area. This was a very transient area with a mostly male population. The sailors' ferries would offload right in this section of town and the working ladies would be waiting for the men on the docks. The Water Street wharves mainly served for timber shipments in the seventeenth and eighteenth centuries. Eventually the wharves gave way to coal shipments and supplies needed to build the ever-approaching industrial revolution. Maritime traffic increased as military ranks grew

in anticipation of the Spanish-American War in 1898. Sailors were not the only ones patronizing the houses of ill repute. Some of Portsmouth's more distinguished residents were also part of the clientele. Many judges, members of the clergy and even policemen were frequent visitors. Ships with European diplomats bound for more northerly destinations such as Portland and Bar Harbor, Maine, stopped in Portsmouth for brief stays.

One of Water Street's houses of ill repute was quite famous. Alta Roberts ran this three-story brick duplex with an iron fist. Activities took place on the first and second floors; the third floor was a bit of a shelter for those who had no place to stay. Alta lived next door in the other half of the duplex. She was known as the "black mystery" of Water Street because she was tall with long red hair, gold teeth and she always dressed in black. There were beautiful paintings on the walls of the rooms and with the push of a button they would slide over to reveal images of suggestive nudes. The fee for services at the time was two dollars, equally split between the girl and the house.

With the navy yard across the water, there seemed to be an endless supply of customers for the red light district. Crime was rampant and in 1912, four sailors were brutally murdered and their bodies were found within weeks of each other in this section of town. A curfew was put in place in order to keep the men out of the district. There are newspaper accounts of men overloading small boats that were rowed across the Piscataqua River and were overturned by the strong currents. It was soon mandated that any officer caught in uniform in these houses would be immediately disciplined. However, where there is a will there is a way. A little shop opened up along the waterfront. It was a most unusual business. They rented street clothes by the hour so that patrons could remain relatively anonymous while visiting the bordellos.

After the 1912 murders, there was tremendous outcry to do something with this embarrassment to the town. One of the first people to come under fire was the police commissioner, who was abruptly forced out of his position. Finally, the houses were forced out of business by the most unlikely of sources. Two sisters, Mary and Josie Prescott, made it their personal crusade to destroy every shed of Portsmouth's seedy red light district. The entire neighborhood no longer resembled the area they knew as children. When their brother passed away, leaving a considerable sum of three million dollars in his estate, the legal wrangling began. There were some debate about his will and questions were raised about how the funds were going to be divided up. The sisters hired an attorney who

contested the will and in a fascinating turn of events, the sisters received the full inheritance. All of the brothels were torn down in the 1930s as the sisters bought out the owners of the properties. The only remaining house of ill repute still stands today, next to the entrance of the park named after the sisters.

Prescott Park is a gorgeous waterfront park filled with grassy fields, an outdoor theater and beautiful gardens. The park bears no resemblance to its shadowed past. A small marker memorializes the patriarch of the Prescott family. The father of the Prescott sisters mysteriously passed away on the top floor of the family's Water Street home. The park attracts people from all over the seacoast throughout the year, but thanks to the Prescott sisters, the past of the area is nothing more than a fading memory. Are the spirits that inhabit the former brothel just a memory?

What was once a three-story tenement house and brothel is now a complex of lovely apartments surrounded by the park. Stories have been told about experiences that residents have had on the second and third floors of the building. Interviewing the relative of a family that lived in the building, I was told that the family decided to move after living there for just one year. They claimed to hear voices inside the walls late at night. When they put their ears up to the wall the sounds were unmistakable. It was also said that from inside one of the closets you could hear a steady banging coming from inside the walls. At first they tried to logically understand what was making the noises. They called in a team of exterminators to investigate and see if they could find animals or pests. When their response yielded no satisfactory results, they called in the plumbers. The plumbers could not offer any explanation, either. After being woken in the middle of the night for about a year, the family decided to move out.

I haven't heard any stories from the new residents in the building. Perhaps they haven't heard anything, or maybe they are just ignoring it. With this part of town's legacy, it would not be surprising to think that something is lingering in the house. A spirit or impression of the past may still inhabit this property. It is thought that some ghostly encounters or phenomena can be a psychic impression. These residual hauntings are thought to be spirits caught in a continuous loop. It is as though a moment in time replays itself over and over again. These instances are even thought to be place memories, which occur when a location captures energy and uses it to record an image of an event that once happened there, and then later replays it. If this building has any memories from the era of the red light district I am sure it has no intentions of forgetting them any time soon.

THE WITCH CAT

There were early accusations of witchcraft in Portsmouth. One of the earliest was in 1656, just a few years before the witch hysteria gripped Salem, Massachusetts, in 1692. Witch hysteria had taken such an extreme hold over Salem residents that nineteen people were executed there for allegedly practicing witchcraft. Once again, Puritan beliefs were the root of the accusations. Puritans thought that Satan would seek out weak people, the women and the feeble-minded to carry out his work. Accusations weren't always based on that belief. Some accusers had other motives. Land disputes and changes in the weather could be blamed on witchcraft—a sin so evil that it was punishable by death. One night in the Portsmouth woods, Susannah Trimmings was returning to her house and met up with the witch Goodwife Walford. The incident is rumored to have left Susannah in severe physical shock and pain. She claimed that when she encountered Goodwife Walford, a shock of fire slapped her on the back and left her limbs frozen and cold. Somehow she managed to struggle her way home. The witch gave her a foreboding message claiming that she would take a long journey, one from which she would never return, and she took that as a curse upon her life. After the message was delivered, Goodwife Walford transformed into a cat, jumped into a tree and then vanished off into the darkened woods.

The story spread throughout the settlement rather quickly. The residents were shocked and frightened to think that the evils of witchcraft had come to Portsmouth shores. After hearing the story of Susannah Trimmings, two children came upon Goodwife Walford and fled from her, screaming all the way home. The tale goes on to say that Goodwife Walford told the children not to be afraid, because the townspeople would think that she bewitched the children, and that she would be put to death.

The paranoia of the townspeople grew as the hours went on. One family's yellow cat disappeared, and it was thought that this cat was the witch. People hid in their homes in terror after news spread. Husbands

and wives gathered with neighbors wondering what to do about the witch menace. One of the husbands claimed to have seen the cat and shot at it several times and yet the cat did not die. Even things as simple as holes appearing in socks were blamed on the witch. Hysteria was settling in with the townspeople who could do nothing but think the worst.

Personal belongings began disappearing, and the loss of a batch of homemade soap was blamed on the witch cat. The next morning lying on the floor in front of the fire was the missing and suspected yellow cat, proudly displaying a rat he had killed. It was discovered that it was the rat that had eaten those mysterious holes in the socks.

The trouble was far from over. Mrs. Trimmings, along with other "witnesses" who maintained that they knew Goodwife Walford was a witch, went to the magistrate and she was brought into custody under suspicion. Although court records dating from this time are scarce, it is said that the charges were dropped. This was not good enough for her accusers, and they still openly called her a witch. Angered by the continuing accusations, Goodwife Walford brought a case of slander against those pointing the finger at her, and she was awarded five pounds for her troubles. Although many still whispered she was a witch, outward confrontations quickly came to an end. If she had lived in Salem, the story may have had a completely different ending.

WENTWORTH BY THE SEA RESURRECTION

The Wentworth By the Sea is one of New Hampshire's grandest hotels from the golden age. This gorgeous hotel was built in 1873 and in its first incarnation it looked quite different than the Wentworth of today; it was rather box-like. In 1879, the hotel was purchased by Frank Jones and under his ownership the hotel became a grand showplace. Frank Jones added the third floor and the mansard roof, along with its very distinctive towers. Frank Jones's home, Maplewood Estate, had a similar personality. Roman columns and beautiful ceiling medallions were just part of the Wentworth's architectural details. The ocean views from the property located on a high bluff are breathtaking; some even say that you could see the New Hampshire White Mountains from the upper rooms in the hotel.

With the style that was so over-the-top, attention to detail was paramount. This was quickly becoming a showplace for its 450 guests. Lavish entertainment was always on the schedule during the Frank Jones years. Lounging while looking at the ocean was just one of the many activities popular with guests. The rooms throughout the Wentworth were strikingly beautiful, offering guests every luxury available, including steam-powered elevators and water closets.

After Frank Jones passed away, the property changed hands, and in 1905 it was host to the delegates of the signing of the 1905 Russo-Japanese Peace Treaty. As the years passed and ownership changed hands, it seemed everyone had a new vision of what the Wentworth should be. Always catering to the most affluent, the hotel was always a destination for New England socialites. The Wentworth had extensive golf courses, a ship-shaped movie theater, spacious tennis courts and costume balls. The property closed briefly during World War II.

When the war was over, times at the hotel were still as grand as ever. With the Wentworth welcoming one thousand visitors a day and hosting extravagant parties, it seemed as though the good times would never end. However, as the 1960s drew to a close, perceptions and needs for a hotel

of this size changed. The lavishness of the hotel's golden age seemed to be caving in on itself. Would the Wentworth survive the very imposing future?

New Swiss owners purchased the property in 1980. However, just one short year later, the once grand Wentworth closed its doors and took a breath. Time was not kind to the aging hotel. The hotel was being undermined by rodents. Disrepair and abandonment loomed on the horizon. What looked like something out of a horror movie set no longer resembled the fantastic days of Frank Jones. Parts of the property were soon sold off piece by piece, and parts of the building were demolished. The Wentworth soon was only about one-third of the size it was when it belonged to Frank Jones.

The ocean air and harsh winter exposure took a heavy toll on the woodwork and the towers. Concerns sprung up as to what was going to happen to the property. In one of the most prime locations on the seacoast, everyone seemed to have an idea—although most of those ideas did not include keeping the hotel. The loss of the hotel was imminent; the money that would have been needed to save the Wentworth was far too great for any localized efforts. All hope seemed lost for what used to be the grand playground for the rich and famous.

In 1999, Hollywood used the decrepit hotel as a backdrop better than set designers could hope for. The aging shell, missing windows and twisted look of the hotel seemed to grimace on screen during the movie *In Dreams*. The tagline for the movie was, "You don't have to sleep to dream." It seems as though the dreams of the Wentworth were slowly turning into a nightmare and the hotel had completely lost itself to the ravages of time.

However, there were some forces working to help save the Wentworth, and demolition was stopped three times. Controversy dominated talks over the future of the hotel. A possible savior had been found. Ocean Properties could provide the capital that was so desperately needed. Twenty-five million dollars was secured and with that, plans began to move forward toward a monumental restoration. Each step of the renovations was carefully watched by locals and historians and chronicled in local papers. Anxiety about what the hotel was going to be like grew day by day. People were worried that the hotel would offer gambling or other activities of which they did not approve. If not for the company's efforts, the property was doomed to collapse in the very immediate future.

By 2003, the seacoast was ready to welcome back the Wentworth By The Sea. The hotel looked gorgeous, and to top it off, it had been decided that the hotel would be restored to its most opulent days—the days of

Frank Jones. A beautiful domed mural of angels was restored. The entire hotel was brought to life, back from the edge of oblivion, for all to visit and enjoy.

With the new renovations, old stories of ghosts and unexplained activity resurfaced at the Wentworth. When the hotel was being prepared for its transformation, a local business owner toured the property. In an interview, the business owner said that she did not believe in ghostly activity before, but that this incident had made her a true believer. As she stepped onto the building site, she said there was the sound of music in the air—music that sounded like it was clearly from the Roaring Twenties. She said that the property was in such disrepair that there was no power at all and that there was no probable source for the music. She looked around hoping to find the location of the music. As she started to make her way around the debris, she felt someone there—someone she could not see. This very tangible spirit she encountered was walking along the property with her as she toured the area. In a fascinating twist, there was still some essence to this decaying property.

Since the hotel has reopened, stories have come from the many employees at the Wentworth. Some of the girls who work at the Wentworth Spa said that they knew for sure that there were spirits at the hotel. They said that they knew people who quit when they saw people dressed as partygoers walking through walls in the dining areas. These entities were also described as dressed in the Roaring Twenties fashion. They said that hearing this type of music was fairly commonplace in the long hallways. In addition, they believed that these spirit encounters were causing some of the housekeeping staff to quit their positions at the hotel. Many of them said that they regularly experienced spirits passing through the walls, and they were always dressed for the party. With all of the gala events that went on at the Wentworth By The Sea, it may not be surprising that some of the guests are still enjoying their stay.

A tour guest sent me an e-mail with a story about the Wentworth. I had done a dinner talk and tour about the Wentworth By The Sea for a national company headquartered on the seacoast. They were very interested in the stories, because they were all staying at the Wentworth and were having all of their meetings there as well. My presentation included images and stories that surprised them, as most of them did not know the Wentworth had sat abandoned for so many years. Coupled with the stories of these mystery Roaring Twenties specters and music, they returned to the hotel a bit enlightened.

The e-mail I received from the group organizer told me that the next day they went to their meeting and there was a problem with the lighting. When they sat down for their discussion in one of the meeting rooms, the lights turned themselves off. After checking the switches, they could not get the lights to stay on. They noticed that other meeting rooms were having no problem with lighting, and the rest of the hotel also seemed immune to this phenomenon. The hotel brought them freestanding lamps and extension cords because they could not solve the problem. The e-mail went on to say that they all remembered the ghostly past of the Wentworth and thought that they too were experiencing the same thing.

The Wentworth has inspired painters, poets and writers over the years. You can visit the galleries in Portsmouth and find many interpretations of this elegant hotel. The colorful sunsets showcase the Wentworth in all its glory these days. From the Route 95 Piscataqua Bridge, you can see the city of lights that the property has become, and it seems like a fairy tale world on the edge of the horizon.

The Wentworth By The Sea is an incredible place to visit. After sitting vacant and__ almost being lost, it has truly seen a resurrection. It seems as though the Wentworth has brought back the ghosts of its past, and they are probably enjoying this place more than ever these days.

CONCLUSION

My intentions in writing this book are to enlighten you and provide instances where history and the paranormal cross paths. Some stories have strong enough backgrounds to present questions and warrant further investigations. Discovering paranormal activity is just one thing to do when you visit this beautiful city. There are wonderful restaurants, delightful shops and welcoming public spaces. If you are not ready to become a believer, perhaps the history will speak to you and prompt you to visit these places. But should you decide to venture into Portsmouth's ghostly past, there are many intriguing avenues to follow. Take the time to talk to shopkeepers and locals and you'd be surprised by what you hear. Should you find that some people aren't ready to share their ghost stories with you just yet, don't let that sway you. I have been pulled aside on tours and told stories by the most unlikely of people. Visit the numerous historic homes that are lovingly restored and carefully decorated with period furnishings. Bring your camera along and be sure to take many pictures. Then you can decide for yourself.

Whatever street you end up on, no matter what part of town you are in, you will soon find out that each building and street corner has its own story and legend to tell. There are so many stories left to tell from the long past of this beautiful town by the sea. Each century has brought a variety of people and new stories to add to the ever-growing history and legacy. Since 2002, when I began conducting tours in Portsmouth, I have heard new stories quite frequently. For me, this is the heart of Portsmouth's intrigue. What will someone share with me on the next tour? Will my next dining companion send me back to the library to do more research?

The Chamber of Commerce's visitor information kiosk is filled with brochures of places to go and things to do. You may even see brochures for my tours. Join us as we continue to look in the shadows of this city's fascinating history. You may want to sit in Market Square, where locals and tourists gather to sit and sip lattes or cappuccinos, unaware of the

stories around them. As you turn the final page in this book, know that you have now taken a journey into the mysterious past of Portsmouth.

The motto of the city of Portsmouth is the "City of the Open Door," and with nearly four hundred years of history there certainly are a lot of stories behind its doors. From the oldest painted murals in the country disguised for dozens of years to handcrafted pottery hidden inside fireplace walls, there is so much yet to learn and discover. My advice to you is to take your time looking around. When you least expect it you might just encounter spirits of the past.

BIBLIOGRAPHY

Aldrich, Thomas Bailey. *An Old Town by the Sea*. Jefferson Press, 1903.

Brewster, Charles Warren. *Rambles about Portsmouth: Sketches of Persons, Localities, and Incidents of Two Centuries*. L.W. Brewster Publishing, 1873.

Brighton, Ray. *Frank Jones: King of the Alemakers*. Peter Randall Publishing, 1976.

Crisp, Kimberly. Water Street Remembered, honors thesis (unpublished). University of New Hampshire, 1996.

Friends of Portsmouth Harbor Lighthouse. www.portsmouthharborlighthouse. org

Grossman, Nancy W. *The Placenames of Portsmouth: Being an Anecdotal Stroll Through the Centuries and Neighborhoods of Portsmouth, New Hampshire*. Placenames Press, 2005.

Knoblock, Glenn A. *Portsmouth Cemeteries*. Arcadia, 2005.

Morris, Zhana, and Trevor Bartlett. *The Music Hall*. Arcadia, 2003.

New England Curiosities, tours and events of local legends, lore and mystery. www.newenglandcuriosities.com

Seacoast NH: America's Smallest Seacoast. www.seacoastnh.com

Small, Connie Scovill. *The Lighthouse Keeper's Wife*. University of Maine Press, 1999.

A Very Grave Matter—Historic New England Burial Grounds. www. gravematter.com

Visit us at
www.historypress.net